FAVERSHAM
THROUGH TIME
Robert Turcan

AMBERLEY PUBLISHING

First published 2010

Amberley Publishing Plc
Cirencester Road, Chalford,
Stroud, Gloucestershire, GL6 8PE

www.amberley-books.com

Copyright © Robert Turcan, 2010

The right of Robert Turcan to be identified as the
Author of this work has been asserted in accordance
with the Copyrights, Designs and Patents Act 1988.

ISBN 978 1 84868 174 3

British Library Cataloguing in Publication Data.
A catalogue record for this book is available from
the British Library.

Typeset in 9.5pt on 12pt Celeste.
Typesetting by Amberley Publishing.
Printed in the UK.

Introduction

Faversham is a hot little town. In fact, it is the hottest in the UK. A record temperature of 101.3 degrees Fahrenheit was registered here on 10 August 2003. The superlative climate – with low rainfall, exceedingly fertile, level soils, and a freshwater stream running into a navigable creek to the sea – has attracted settlers since the earliest times.

Some of the first were the Belgae from the continent, who left behind the remains of their habitation. The Romans followed and it is possible that Durolevum, the town midway between Canterbury and Rochester, was sited here. They certainly had a fort at Bysing Woods near Stone, and there is a Roman mausoleum nearby.

By the early medieval period, King Stephen and his wife Matilda put Faversham on the map with the construction of a massive abbey. This building was larger than Rochester Cathedral and for a brief time the town was the capital of England.

In later years, the port became a leading exporter of corn and wool. This economic growth led to Faversham's membership of the Cinque Ports, as a limb of Dover. A high degree of autonomy and many financial privileges resulted. But obligations followed; by the time of the Spanish Armada, the town was expected to supply a fighting vessel ready for combat.

The dissolution of monasteries during the Reformation saw abbey buildings sold to a local magnate for scrap. The Caen stone, used to build them, returned to France to be used in fortifications at Calais. The demise of the religious establishment meant that a more diverse economy could develop in Faversham. Locals had always strived for independence and it was no surprise that during the English Civil War they supported the parliamentarian cause. During the decline of the Stuart dynasty, a fascinating incident occurred when James II tried escaping to France and was apprehended by local fishermen.

Cessation of civil and ecumenical strife did, however, generally encourage a more expansive international policy. Military might and weapon superiority were advancing rapidly with the now universal use of gunpowder. Faversham was the cradle of this industry in England. Explosives from the town's factories were used at Trafalgar and Waterloo and in civil engineering projects across the growing empire.

Home construction was similarly advancing apace, so nearby supplies of suitable loam were excavated and supplied to a flourishing brick-making industry. These heavy loads were hauled to mainly London markets by sailing barges along creeks and other waterways, and up the Thames. An ancillary activity of boat-building thus arose alongside more traditional shoreline occupations such as oyster fishing.

Today, Faversham is famed for its brewery industry. Britain's oldest brewery, Shepherd Neame, has its headquarters here and hops are still farmed locally. Likewise, fruit growing is a major agricultural enterprise. At Brogdale, a national collection of over 4,000 different varieties can be found.

Beautiful scenic countryside is matched by the warm ambience of medieval streets. Resistance to town planners' schemes for demolishing Abbey Street and constructing of a ring road have proved fortuitous. This historic market town's unique character owes much to its people. Its rich heritage has been well preserved and documented. Over 100 books about this modest settlement of around 17,000 souls exist – a distinguished and distinctive past tends to attract literary attention.

This book attempts to highlight many of the subtle changes that have occurred in Faversham during the age of photography. It illustrates a largely unknown gem which, because it is, mercifully, not on the road to anywhere, retains its old-world pace of life and communal strength.

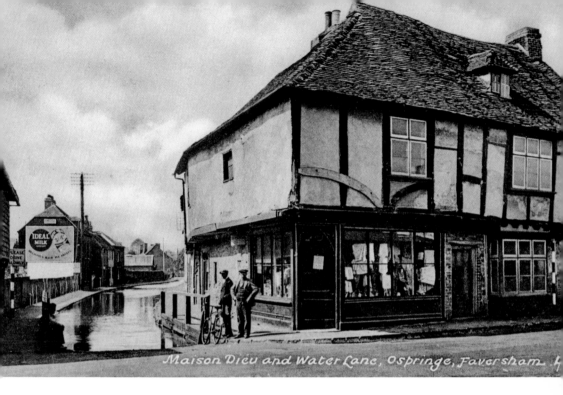

Maison Dieu and Water Lane, Ospringe, Faversham. 4

The House of God

Maison Dieu was established in 1234 under the direction of Henry III. It provided royal lodgings for important persons travelling along Watling Street. It also served as a hospital and monastic hostel for pilgrims and lesser mortals. Closed by Henry VIII during the Reformation, it eventually became, in 1925, England's earliest village museum, exhibiting rich archaeological discoveries from nearby Roman and Saxon sites.

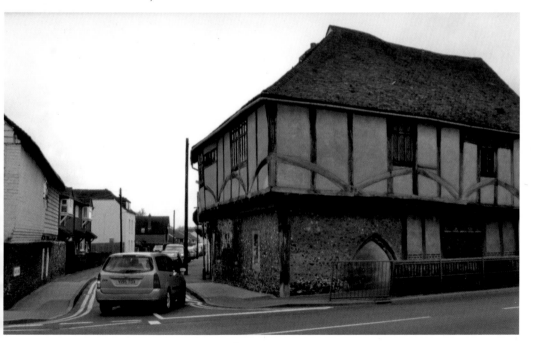

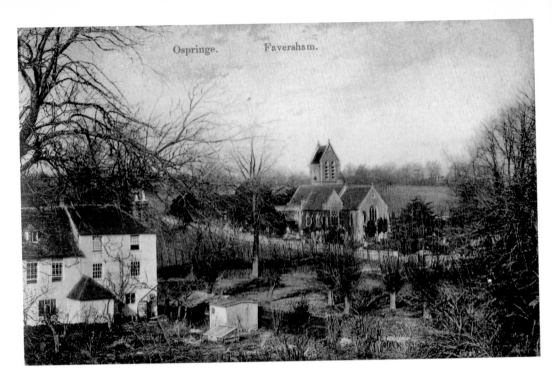

Ospringe.　　　Faversham.

Ospringe Church

The church dates from Norman times. As the name denotes, it was built near a freshwater spring, which has had special significance since the pre-Christian era. Its unusual saddleback tower dates from 1866, and was the ultimate replacement for a round tower that collapsed in 1695 during a peal to salute William III on his passage along Watling Street.

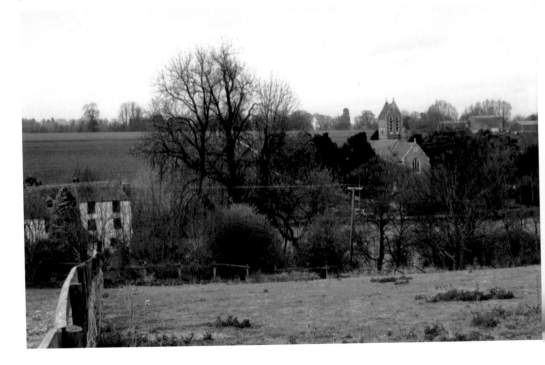

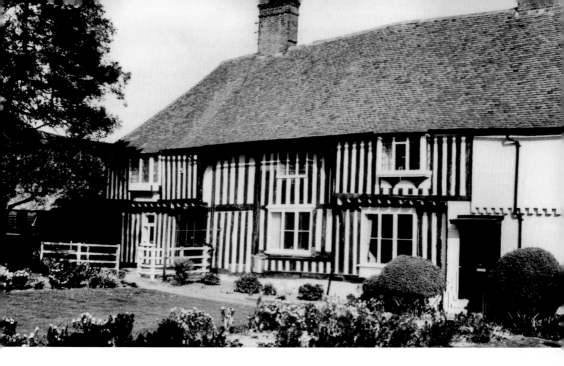

Queen Court, Ospringe
As the name implies, this was the property of successive medieval queens. During the fifteenth century, a classic example of a Wealden hall house was erected; it survives surrounded by ancient and modern farm buildings. Acquired by the local brewers Shepherd Neame in 1944 to supply hops, it is now a leased farm, producing mixed crops.

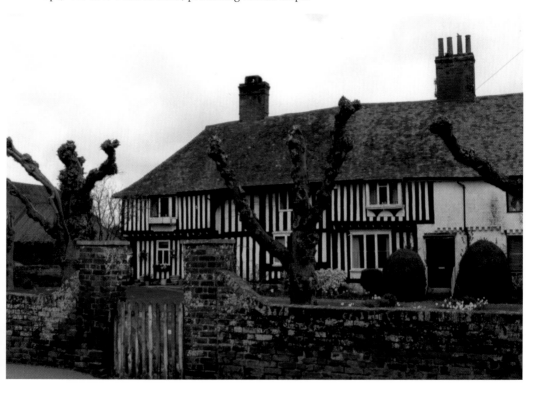

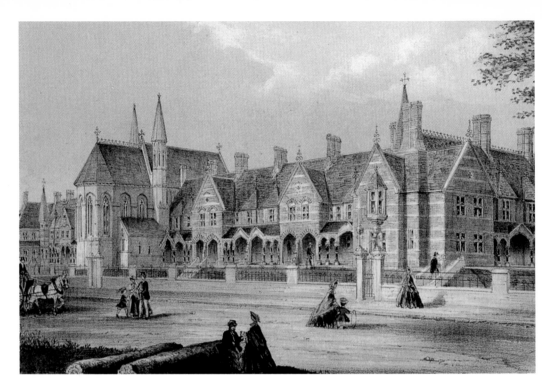

A Valuable Legacy

Henry Wreight, bachelor, solicitor, mayor, and munificent benefactor to his beloved town of Faversham, left his estate of around £70,000 to be spent on lasting amenities. Perhaps the most striking are the almshouses erected in 1863. Designed for seventy pensioners by two relatively unknown architects, the overall scheme is universally admired for its visual appeal. Although colossal, they are cleverly broken up by a central chapel, arched walkways, and interesting gabled roof features. Complementary materials contrasting colour and texture add to the pleasing appearance.

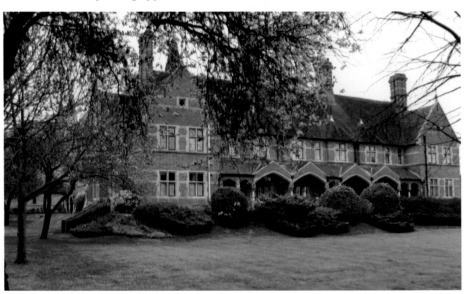

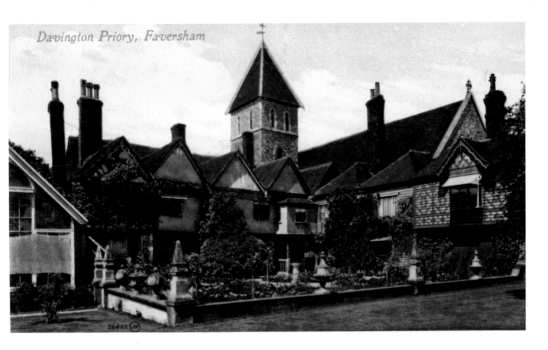

Davington Priory, Faversham

Davington Priory

Established in 1153, soon after Faversham Abbey, Davington Priory held a community of Benedictine nuns, the last of whom died in 1535. Parts of its structure now comprise a parish church and the home of Bob Geldof. Thomas Williment (1786-1871) bought the property and lavished much care on its sympathetic restoration. He is best known as the artist who instigated a renaissance in stained glass painting.

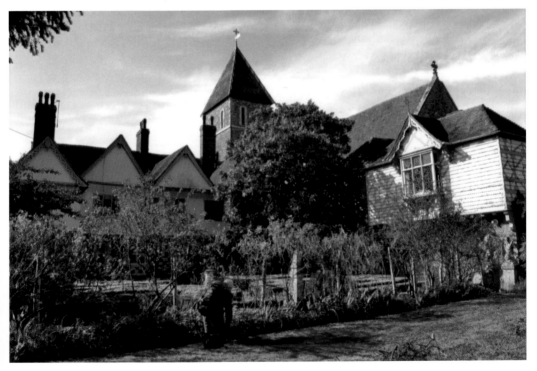

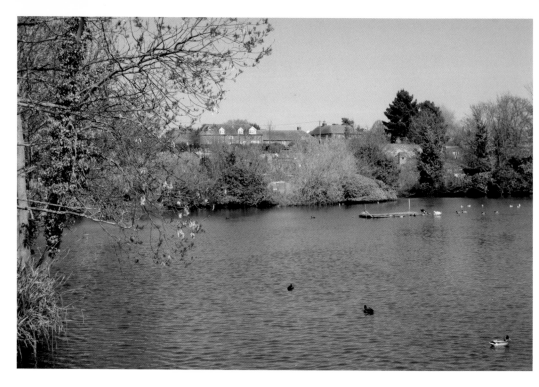

Stonebridge Pond

During the early 1980s, this picturesque spot in Faversham was generously offered to Swale Borough Council for purchase at £20,000 by its publicly spirited owner. Forming part of the water system that fuelled the original Chart Mills, the pond is now a magnet for wading birds and those wishing to feed them.

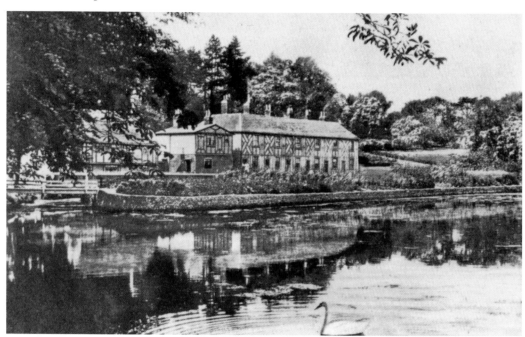

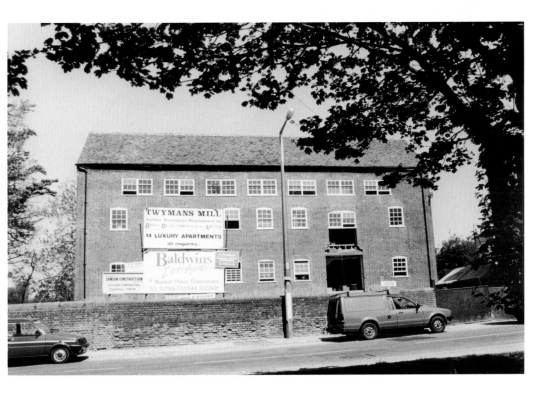

Twyman's Mill

Carefully converted into luxury flats, this old watermill for grinding corn was once a warehouse for a local firm that supplied agricultural goods. It is yet another example of the hundreds of old buildings that have been adapted for modern purposes in the heritage-conscious town of Faversham.

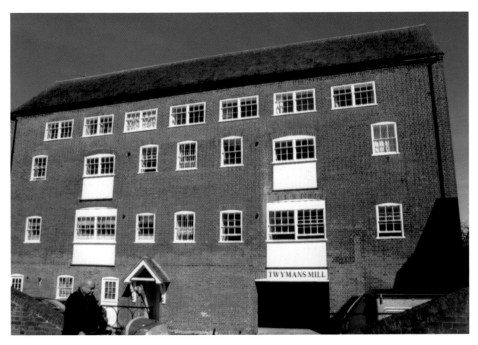

The Patron Saint of Lost Causes

The story of Our Lady of Mount Carmel Roman Catholic Church, Tanners Street, and the shrine of St Jude is a remarkable one. Originally, the chapel was a Quaker school built by the gunpowder manufacturing family, the Halls, for the children of their workers. It was on the site of a tannery. When the school closed, it became a cinema showing silent movies. After the Empire Picture Hall became redundant, it was acquired by Carmelites, who printed pictures of saints for distribution, including pictures of Jude. Eventually, a statue was donated. The house of worship is embellished with a fresco by Edward Ardizzone, a successful illustrator, war artist, and children's author, who retired to a nearby village.

Brick-making

Faversham was at the turn of the century surrounded by eleven brickfields. Their output, conveyed to London in sailing barges, contributed to the mushrooming growth of metropolitan areas. The only remaining manufacturer is Lambs, which took over Cremer and Whiting. The firm produces high-quality handmade bricks and is very fortunate to retain the skills of Terry Hopkins and Barry Parks – seen here at work in Davington. Together, they boast sixty-eight years of faithful service to this venerable business.

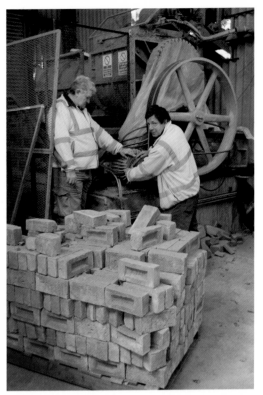

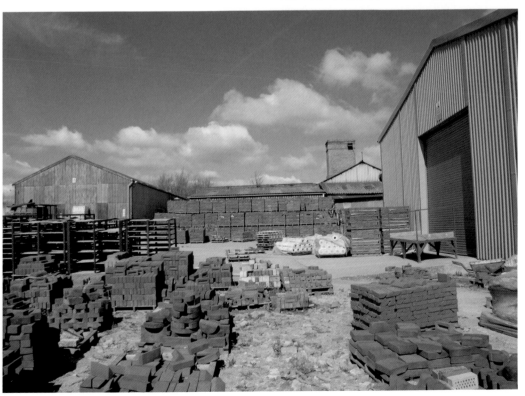

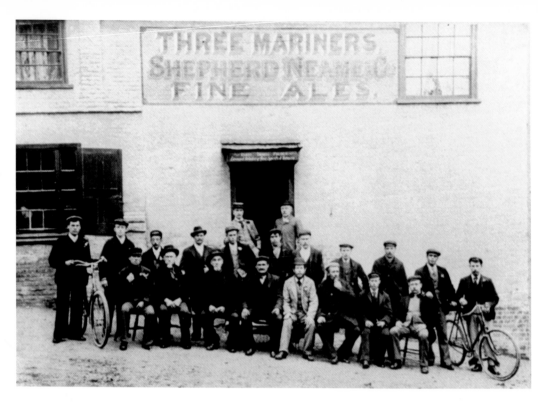

Faversham's Public Houses

Yet another unusual statistic regarding Faversham is that it was once the town with the highest density of pubs in England. This is easily explained; it is a port and a brewing centre. The all-male drinkers posing outside Three Mariners in Oare around 1900 would be considered odd today at a heterogeneous pub like The Sun Inn, West Street.

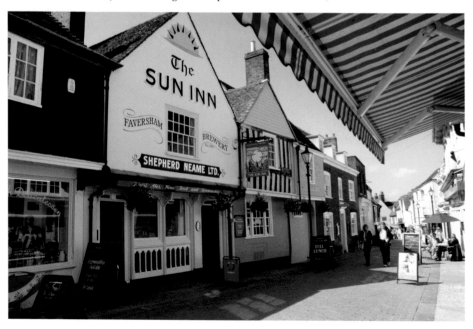

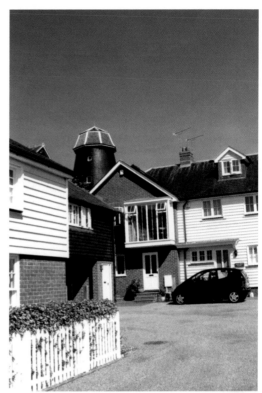

The Windmill
One of the many pubs to have closed in Faversham is The Windmill, named after the windmill that once operated on this site. The once-redundant buildings have since become desirable homes.

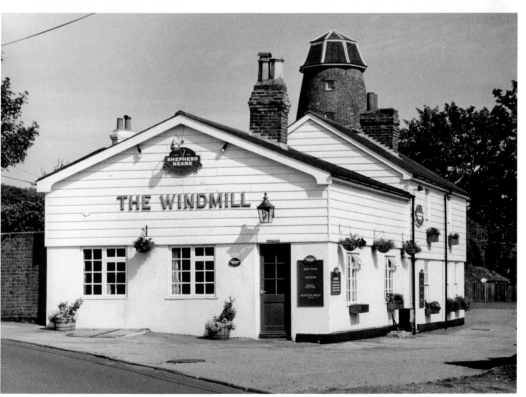

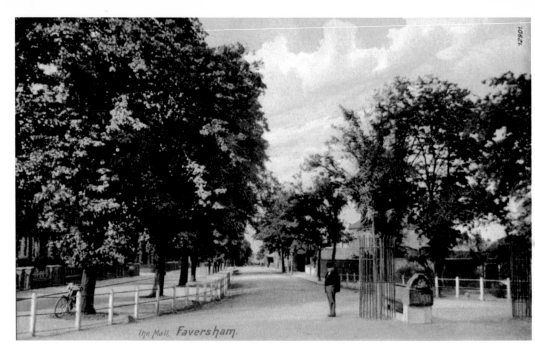

The Mall. Faversham.

The Mall

Opened in the late eighteenth century, the Mall provided a dignified approach to the town from Watling Street. Substantial, well-built villas followed its construction; they are now sought-after homes of character. The horses' drinking trough in the bottom right of the picture is preserved *in situ*.

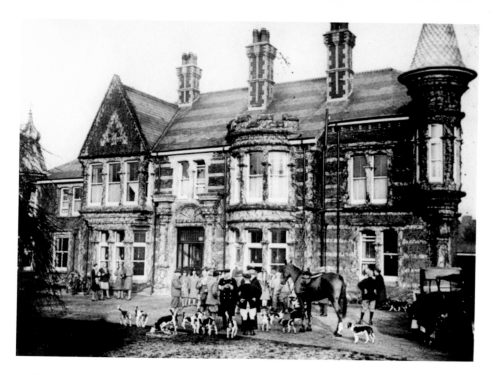

Tickham Fox Hunt

Ticham fox hounds gather in front of Faversham residence before one of their regular excursions into the countryside. The pack was kennelled at Rushett in a purpose-built Victorian complex provided by one Mr Rigden, a dedicated follower of hounds. Depicted below are keen race-goers at the annual point-to-point meeting almost 100 years ago. These races are still held today at Detling and a regular feature is the Rigden Memorial Trophy event.

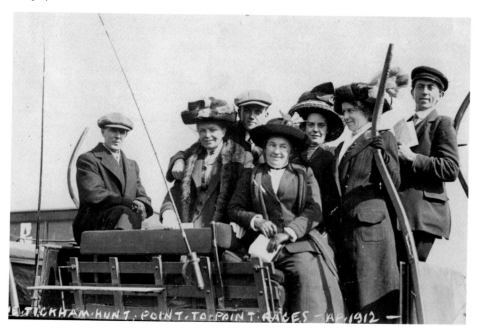

TICKHAM HUNT. POINT-TO-POINT RACES - AP 1912

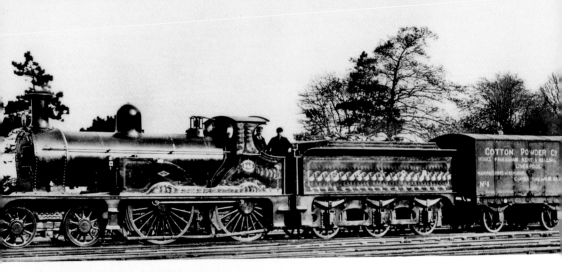

Locomotives

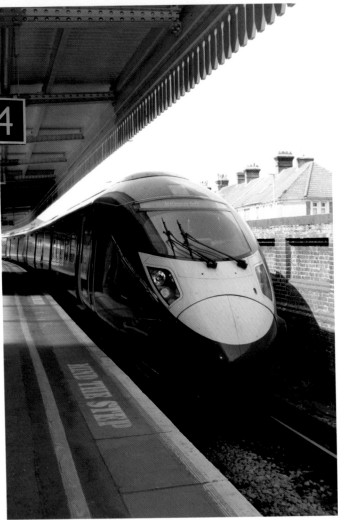

The steam train above could be used to transport guncotton from the Hall family's nearby factories, as it was far less likely to ignite than black gunpowder. Rather than fire alone, it required the shock wave from a detonator to cause an explosion. In stark contrast is the latest rolling stock on the North Kent Line. It consists of the high-speed, Japanese-designed Javelin trains. They are currently underperforming, due to an uncompetitive fare pricing policy.

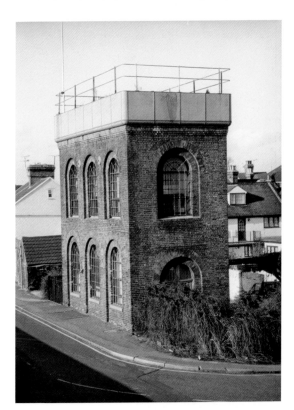

Water Tower, Faversham Station
Originally constructed to provide water for replenishing tank locomotives, this striking building is now a unique home conversion.

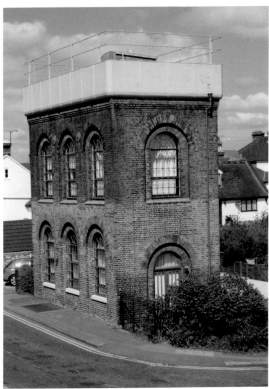

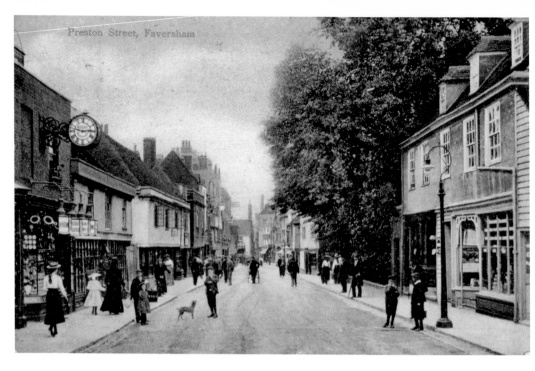

Preston Street (1)

Confusingly for photographers and historians, the wall clock on the left-hand side of Preston Street has been replaced by a similar one further down the street. Once a separate community, Preston has over the years merged with the main town.

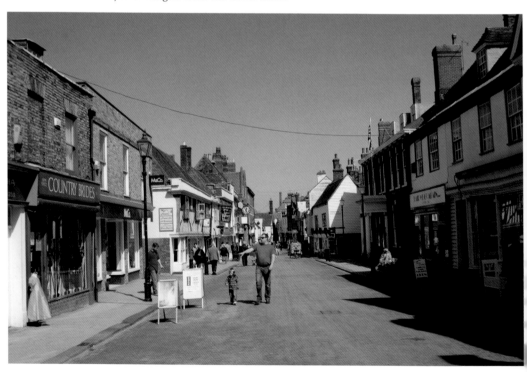

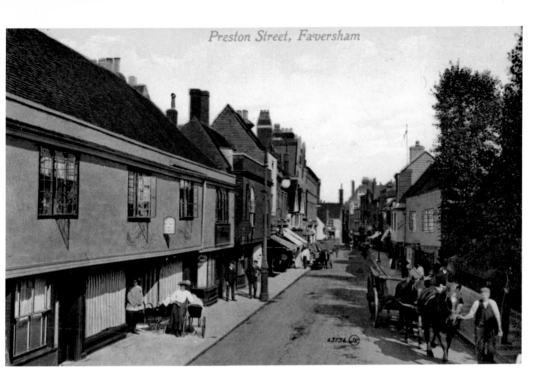

Preston Street (II)

Preston Street is little altered by time and only distinguishable over the century by the clothes people wore, a horse and cart and the questionable modern tendency to remove stucco, revealing the timber frames of ancient buildings.

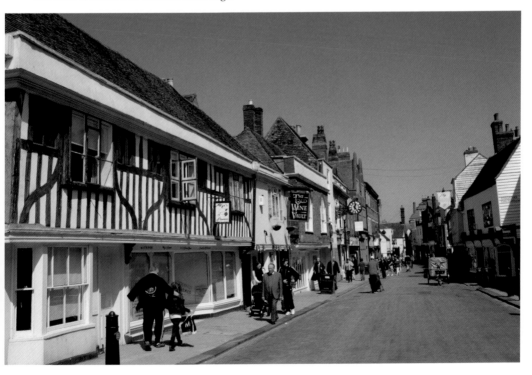

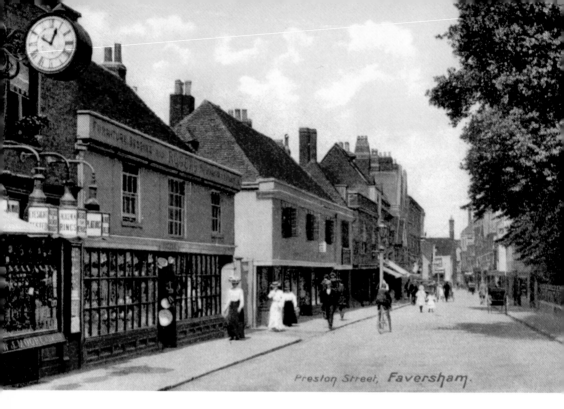

Preston Street, Faversham.

Preston Street (III)

So minor and discreet are the changes in this scene over the last 100 years, these photographs could be used in a spot-the-difference competition.

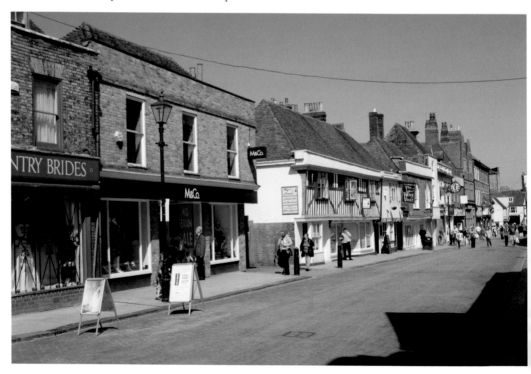

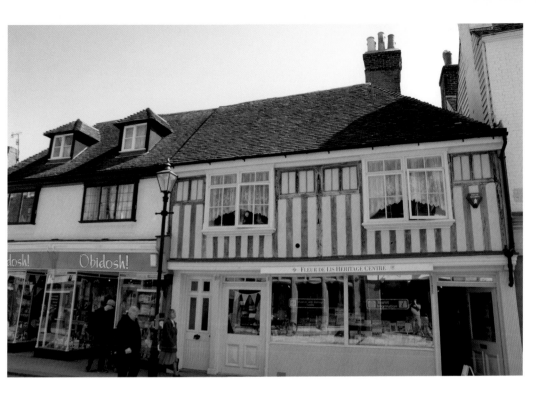

Preston Street (IV)

With the clubs and societies based in the now-demolished Faversham Institute on East Street, the town has for a long time been a cultural oasis in north Kent. Today, the Faversham Society is a thriving and effective organisation that supervises the Fleur de Lis Museum and Gallery on Preston Street. The Heritage Centre, with the visible timber frames, is a few metres to the left of the Museum and Gallery.

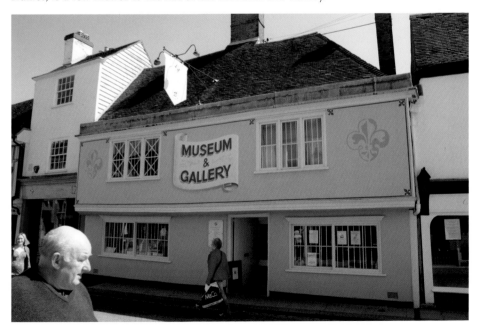

East Street (I)
Cooksditch is one of the several fine brick-built Georgian villas that survive in Faversham today. Presently without the wall creeper, what was once the home of Mr and Mrs Gillow is now a home for senior citizens.

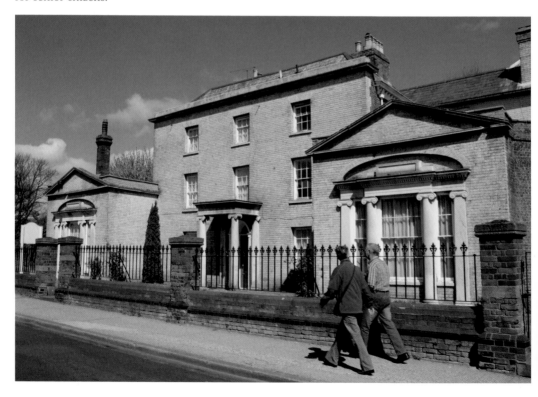

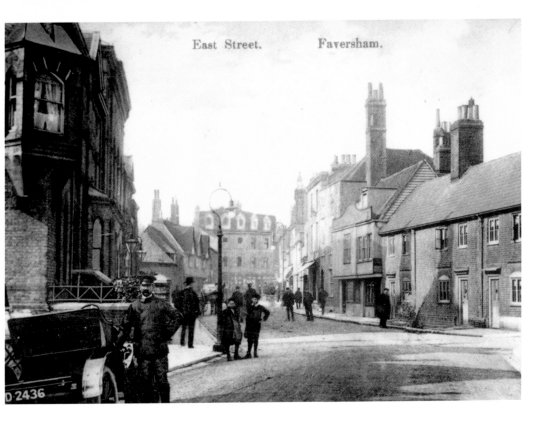

East Street. Faversham.

East Street (II)

The home of the Faversham Institute is on the left in the old postcard; it has been replaced by new flats. A road now runs in the gap where the buildings on the right used to be.

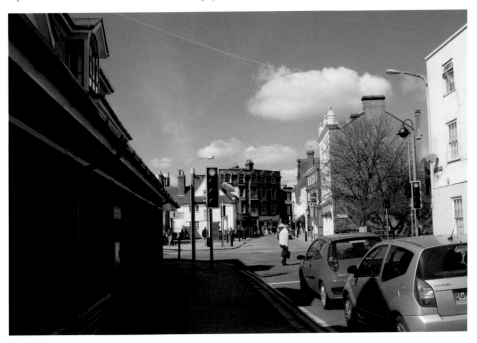

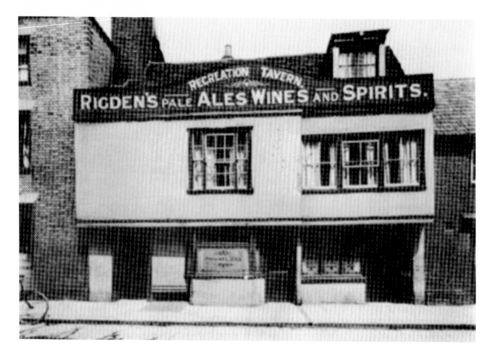

East Street (III)

Recreation Tavern, shown in this very poor quality photograph has, like many pubs, has been converted into a restaurant. The 'Private Bar' sign in the bay window and the hidden words 'Bottle and Jug Department' on the window of the middle door are now rarely seen on modern public houses.

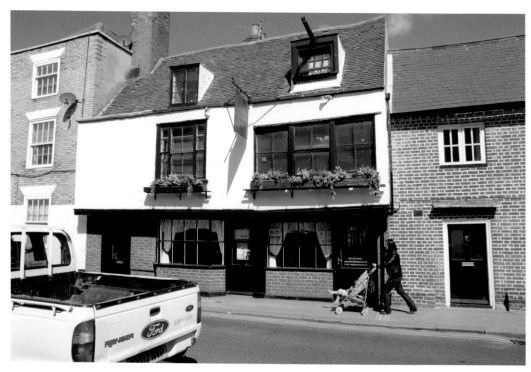

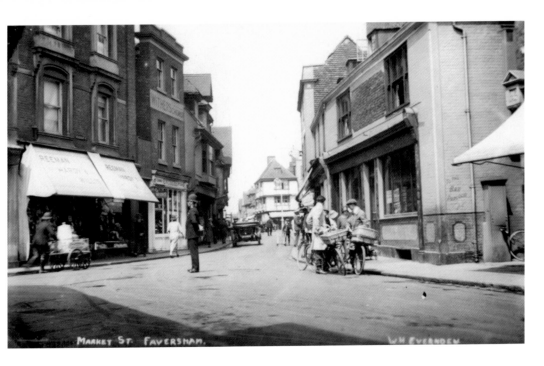

Market Street
The policeman on duty above is at the junction of Preston Street and Market Street. He is patrolling the main spine of the town, which runs north-south along Abbey Street and Court Street, then through the market and along Preston Street. Thanks to traffic restrictions, pedestrians continue to enjoy a relaxed atmosphere.

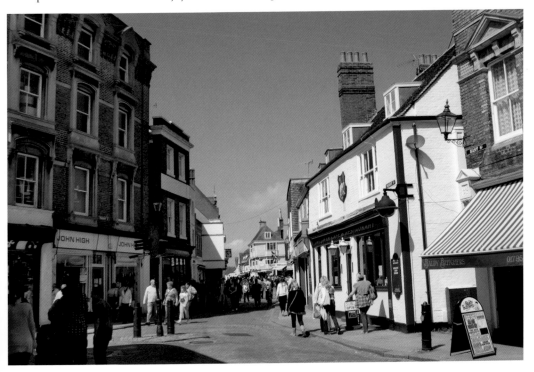

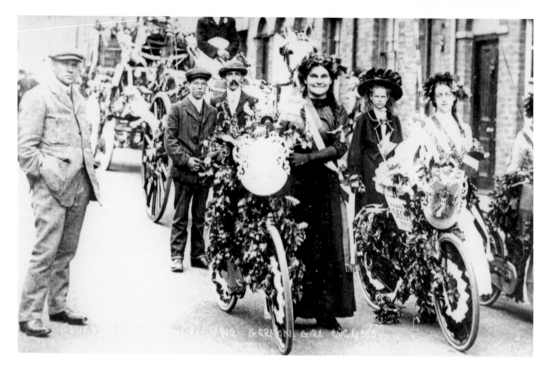

Beauty Queens

Faversham Carnival Club was formed in 1890. The Faversham International Hop Festival and the Faversham Classic Car Show are more recent creations. Some of the early floats were quite intricate; they must have involved many hours of preparation.

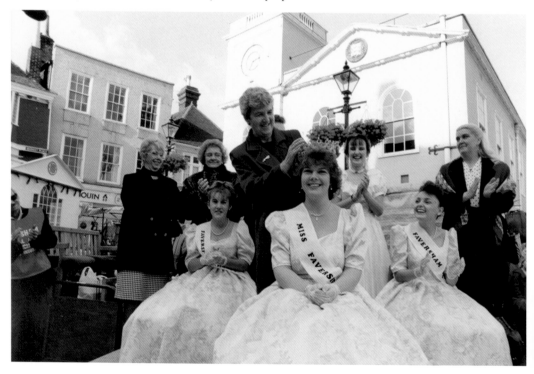

Carnival Floats

Here are examples of two breathtakingly well-constructed horse-drawn floats from 1913. The two breweries, Shepherd Neame and Rigden's, submitted these entries amidst very keen competition.

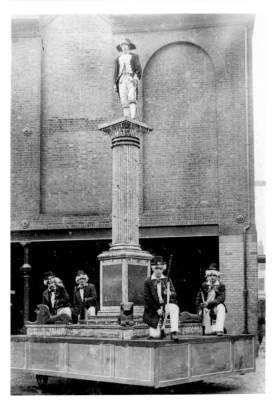

"MOSCOW BELL TOWER"
BY SHEPHERD NEAME & CO
FAVERSHAM CARNIVAL 1913

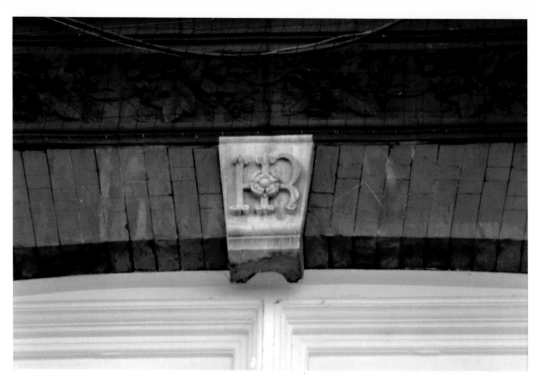

Rigden's Bank

This is one of the joint-stock banks that have survived. Over the years, its ownership has changed hands many times; today it is 84% owned by the taxpayer. One of the early proprietor's initials can be seen in the red-brick façade of National Westminster's branch office (the hop motif in the frieze hints toward his other business activity). The five-pound note has been encashed, as the bottom signature has been cut off. The Rigden family, at the height of Victorian splendour, undoubtedly commanded much respect in the locality as brewers, bankers, landowners, and leading fox hunters.

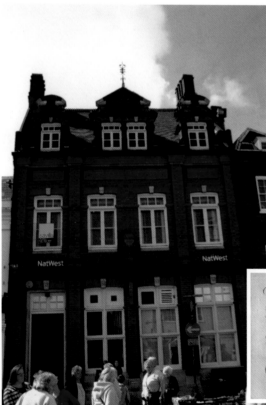

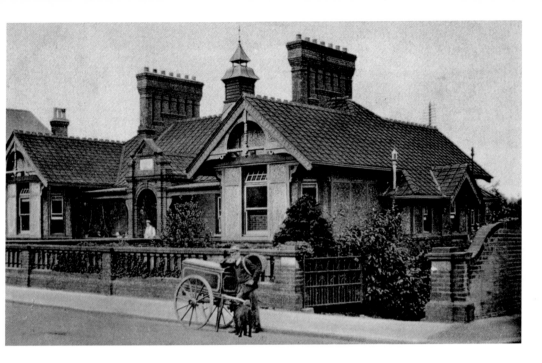

Cottage Hospital

Before this hospital was built in 1887, patients had to travel to Canterbury for treatment. The generous offer of £2,000 by Mrs Townend Hall largely facilitated its creation. Land for its development was donated by the esteemed local businessman Mr John Rigden. The gift from Mrs Townend Hall was a memorial to her husband, the proprietor of a local gunpowder factory. They lived in Syndale Park, Ospringe.

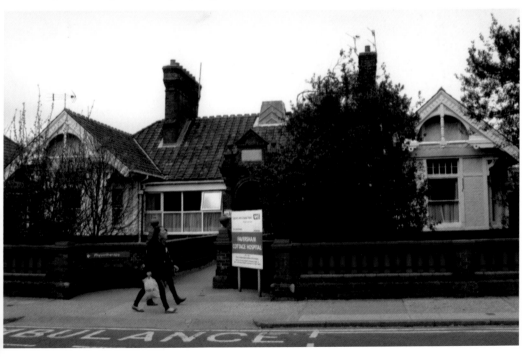

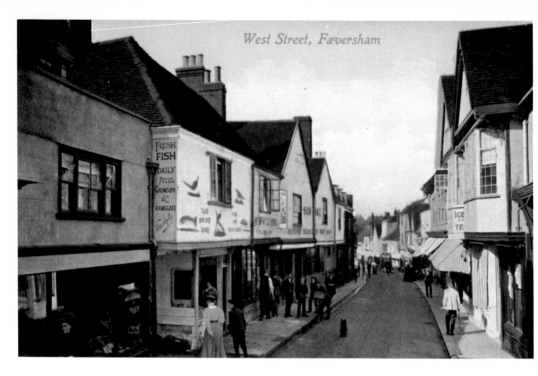

West Street, Faversham

West Street

Retaining much of its original character, West Street winds downhill from the market square. This precinct abounds with interesting shops and a variety of attractive hostelries. Notable amongst these is the Shepherd Neame public house, The Sun Inn.

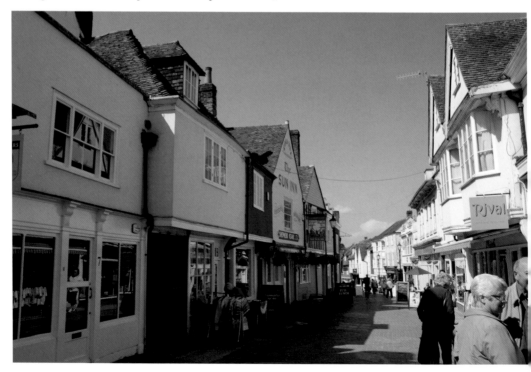

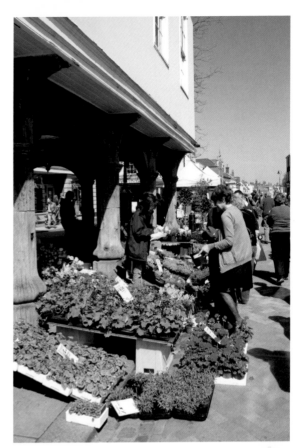

Market Place
Reputed to have one of the oldest markets in England, Faversham boasts thriving regular trade to this day. A wonderful area for assembling crowds, it was milling with smartly dressed revellers on the occasion of the coronation of George V in 1911.

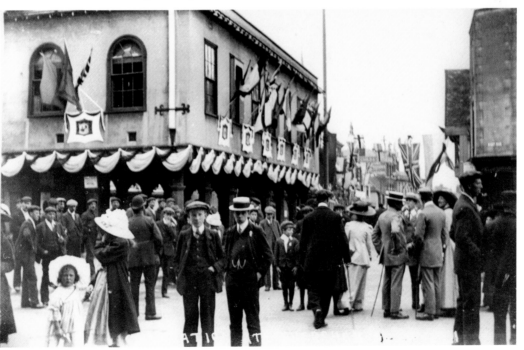

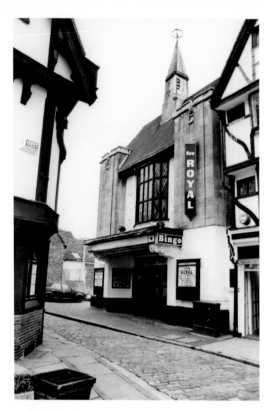

The New Royal
This independently owned, Tudorbethan-style institution is a rare example of a functioning 1930s cinema. Bingo is no longer on offer, but the picture house offers a good selection of mainstream features and more esoteric films.

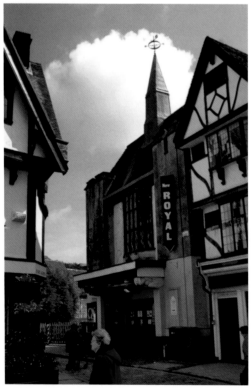

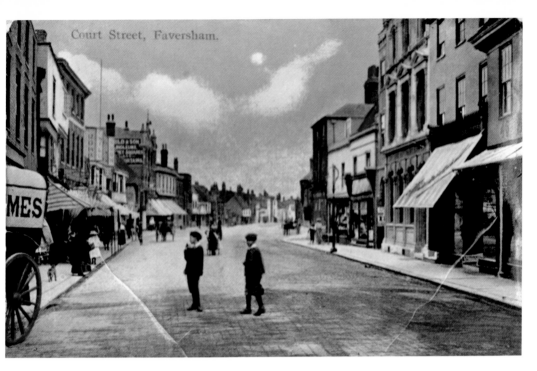

Court Street (I)

Court Street is a vibrant cobbled boulevard that has changed little over the past century. The shops and the goods offered, however, would be unrecognisable to Edwardian consumers. Currently cafés and restaurants line the pavement so that customers can enjoy al fresco refreshment.

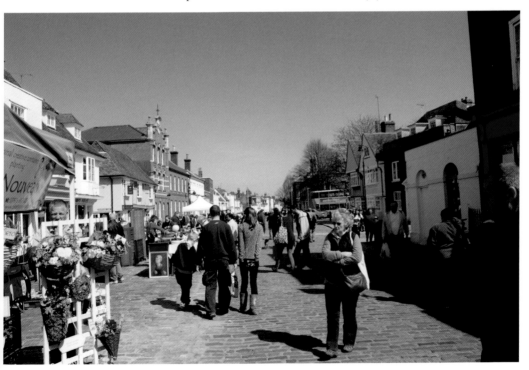

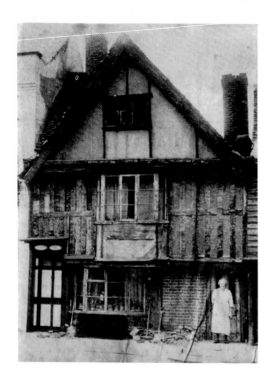

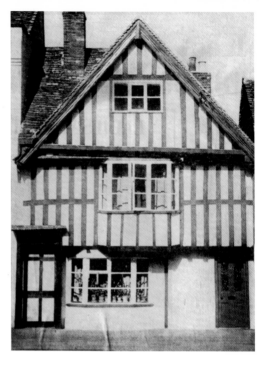

Court Street (II)

It is to the eternal credit of Faversham's civic leaders that they have enacted a policy of restoration and maintenance in what is now recognised as one of the finest medieval streets in England. Previously, many of these half-timbered houses were empty and boarded up and in sad condition. The work was supervised by architect Anthony Swaine, a specialist in this field. Even the paintwork is contrived in a complementary fashion.

Murder Most Foul

The aphorism that no one is more loathsome than a good husband was true in the notorious case of Mayor Thomas Arden, who resided in the Abbey Gatehouse. In 1550, his young wife Alice and her lover arranged the murder of the old boy. For her sins, Alice was burned to death. The tragic tale was recorded in Holinshed's *Chronicles* and then published as a play, *Arden of Feversham*, in 1592. Occasionally this eerie drama is re-enacted in the grounds of Arden House. A modern theatre named after the unfortunate mayor can be found near the town's swimming pool. Faversham has a long tradition of drama productions.

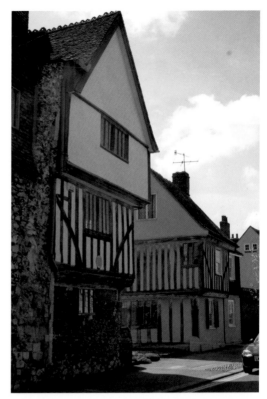

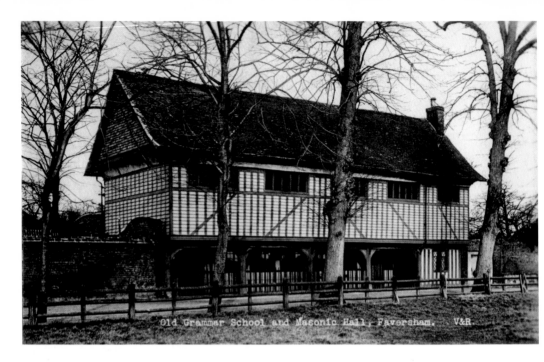

Old Grammar School and Masonic Hall, Faversham. V&R.

The Old Grammar School

This is a rare example of an Elizabethan schoolhouse. It has a first-floor classroom and a covered play area below. The school opened in the first quarter of the sixteenth century with an endowment; Faversham Abbey was to be the trustee. However, with upheavals of the Reformation, the school closed temporarily. In line with Faversham's traditional approach to self-sufficiency, funds for a purpose-built school were raised in the 1580s. It is now a Masonic Lodge, but the carved initials of past pupils remain.

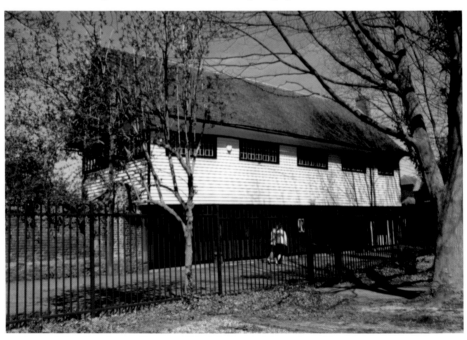

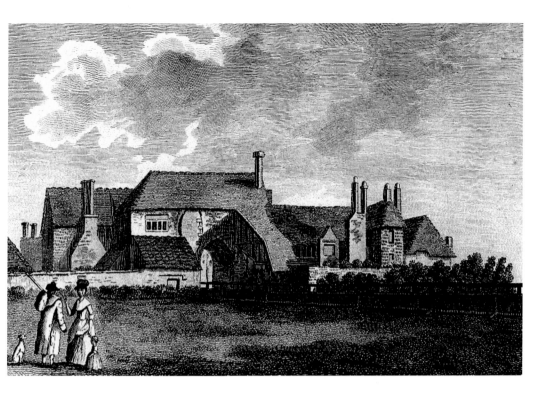

Faversham Abbey
The original building was 360 feet long. It was designed to be the resting place for King Stephen and his family. However, with the dissolution of the monasteries, Stephen's remains were thrown into the creek so that his lead coffin could be salvaged. A ridge in the playing fields of the Queen Elizabeth Grammar School indicates the edge of the building.

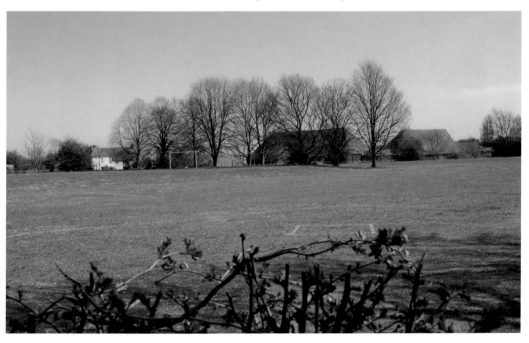

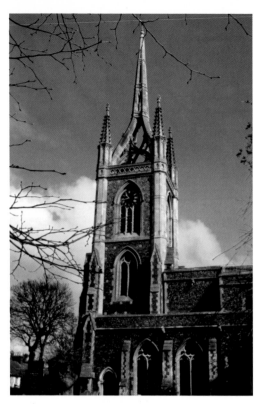

Faversham Parish Church (I)
The size and magnificence of this house of worship illustrates Faversham's prominence in medieval times. Memorials to King Stephen and his wife Queen Matilda can be found inside. The restoration by illustrious architect Sir George Gilbert Scott is generally viewed as sympathetic.

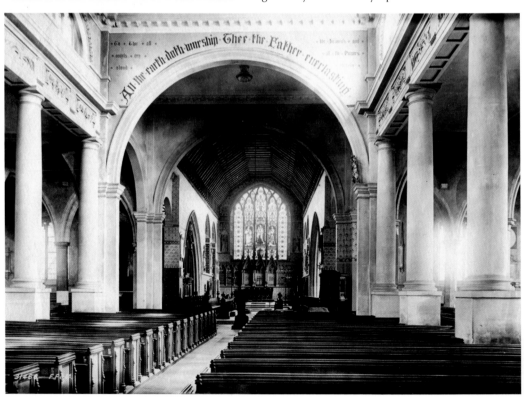

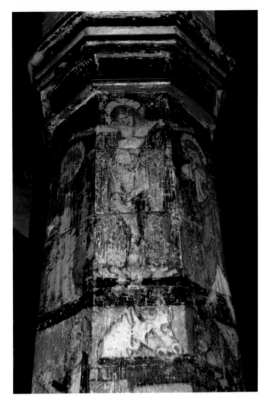

Faversham Parish Church (II)

These rare murals on a column of Faversham Parish Church illustrate how most churches would have looked before Catholicism was superseded by the Church of England's more austere approach to decor. The graceful and pleasingly light spire – with steeplejacks aloft – might have been the inspiration for M. Eiffel of Paris Tower fame. It may be an apocryphal story, but legend has it that the French architect was so taken with the design of the church tower that he alighted from a London-to-Dover train to take a closer look.

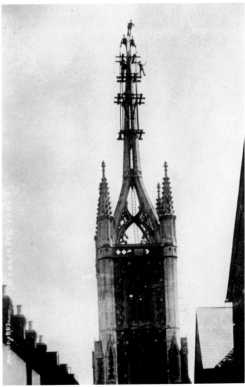

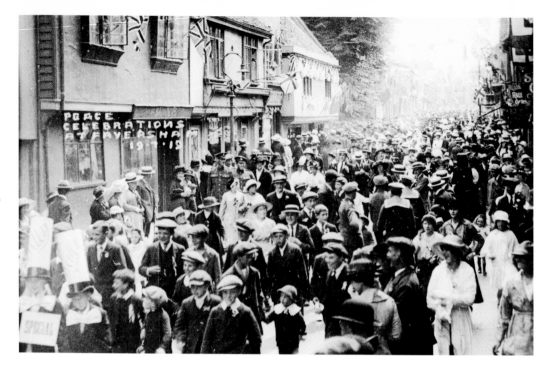

Street Celebrations

Thronging on the streets of Faversham, the town's population celebrates the peace following the First World War. In contrast to the modern crowd marking an Elizabethan anniversary at the quayside, everyone in 1918 is wearing a hat.

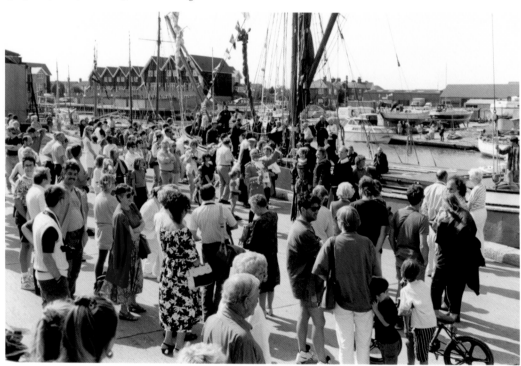

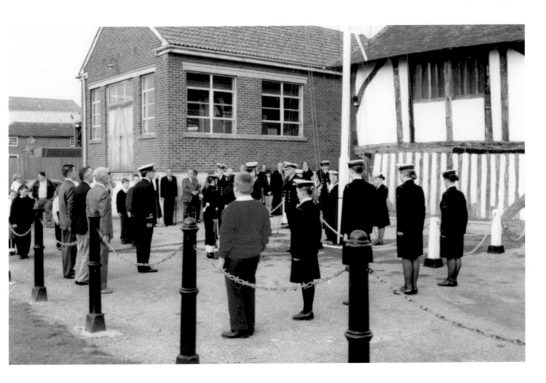

Sea Cadets

On parade outside their splendid period headquarters are the Faversham Sea Cadets. Their clubhouse was constructed in around 1476 as a town warehouse. The unit is named TS Hazard, after the ship Faversham supplied for the battle against the Spanish Armada in 1588.

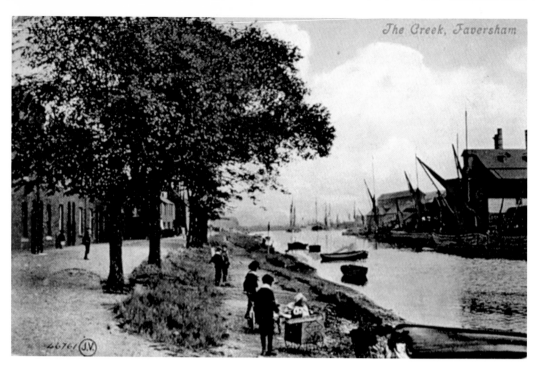

The Brents (I)

Pretty artisans' cottages still line the western bank of the creek, although they now have company; the newer developments are opposite.

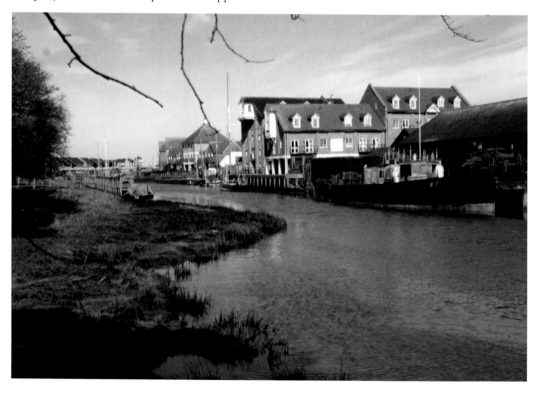

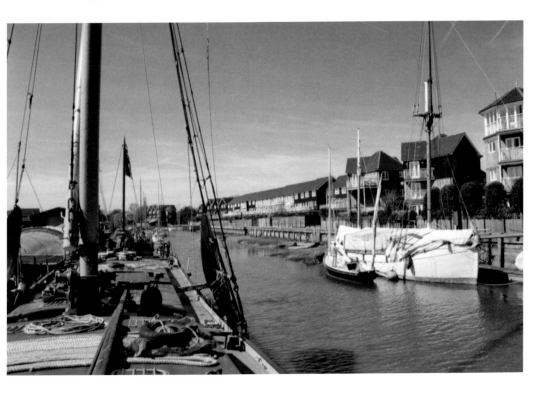

The Brents (II)

This lower reach of the Creek has been redeveloped, as is shown by the moorings and executive apartments in the picture above. The name 'Brent' derives from Brant Geese, who migrate to this area. It was once believed that these aquatic birds emerged from barnacles and not eggs, so could be eaten on Fridays without contravening the prevailing religious convention. Remarkably, this fallacy is apparently the fragile basis on which Faversham's massive ecclesiastical establishment was founded.

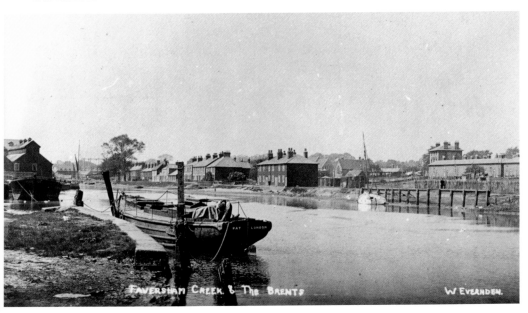

FAVERSHAM CREEK & THE BRENTS W EVERNDEN.

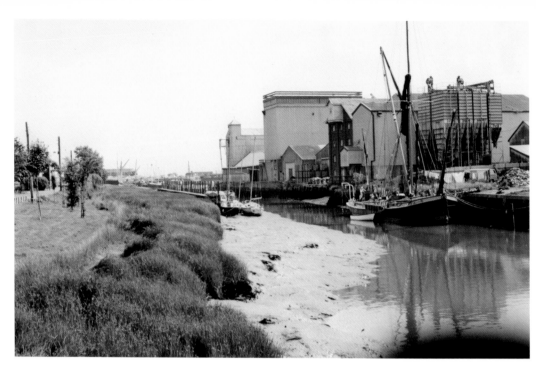

Faversham Creek

The 1970s black and white photograph, which looks east, was taken when this district was chiefly industrial, with corn mills, wharfs, animal feedstuff processors, and warehouses. It has since been transformed into smart waterside housing, a testament to good brownfield regeneration.

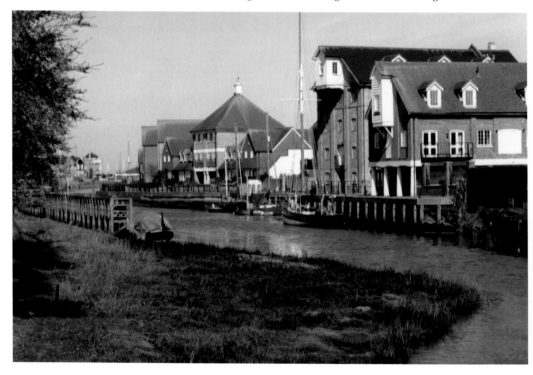

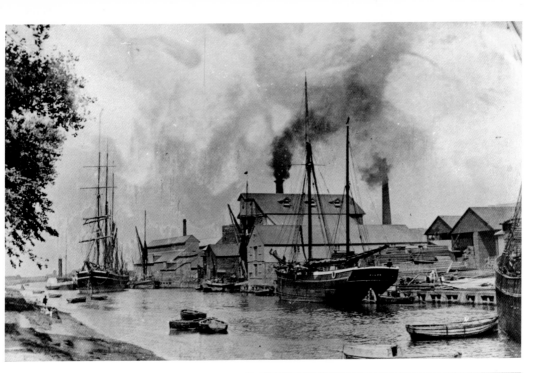

Faversham Oyster Industry

The Guinness Book of Records states that Faversham's original company of oystermen, started in 1189, is the oldest incorporated firm in the UK. These crustaceans have been consumed in abundance since Roman times. When tall ships were tied up at the town's quays, the trade was always brisk. A combination of factors means that oyster fishing in the area has now declined considerably.

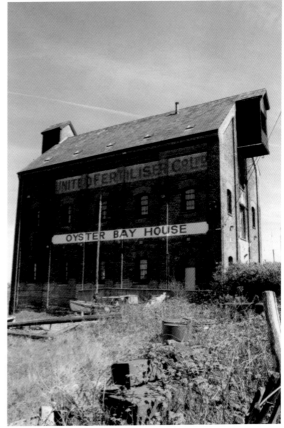

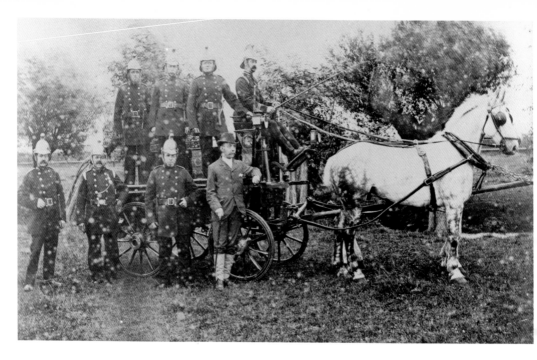

Firefighters Ready for Action

Before setting out for a fire in the old days, it was necessary to harness the horse. Today, this part of the preparation simply involves the turn of an ignition key. Nonetheless, Faversham had several very effective fire brigades proudly competing against each other. The town was extremely vulnerable to explosions and fires, due to its prominent gunpowder industry.

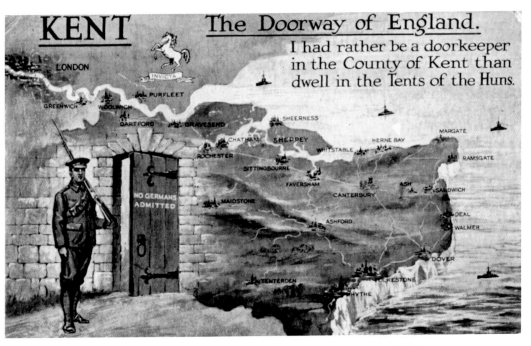

KENT The Doorway of England.

I had rather be a doorkeeper in the County of Kent than dwell in the Tents of the Huns.

NO GERMANS ADMITTED

LONDON · INVICTA · PURFLEET · GREENWICH · WOOLWICH · DARTFORD · GRAVESEND · SHEERNESS · MARGATE · CHATHAM · SHEPPEY · HERNE BAY · ROCHESTER · WHITSTABLE · RAMSGATE · SITTINGBOURNE · FAVERSHAM · CANTERBURY · ASH · SANDWICH · MAIDSTONE · DEAL · ASHFORD · WALMER · DOVER · TENTERDEN · FOLKESTONE · HYTHE

The First World War

The Great War had a tremendous impact on the people of Faversham. Munitions output was vastly increased and many men and boys marched off to Flanders, never to return. A local hero who did was Philip Neame, who received the Victoria Cross. To keep up morale, propaganda postcards were issued, such as the typically jingoistic one above.

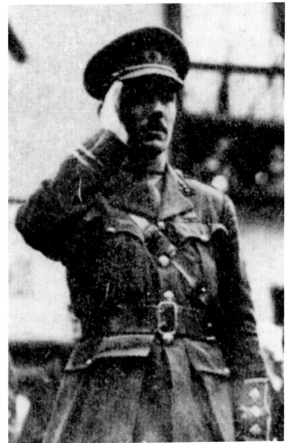

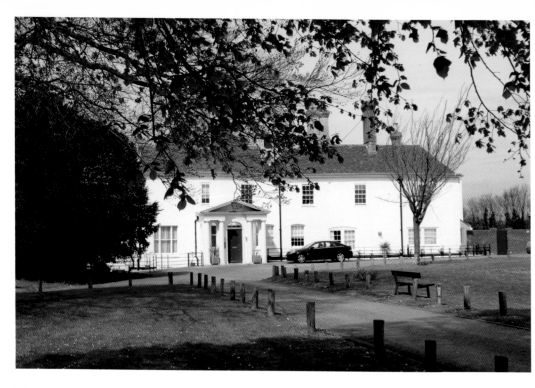

The Mount

The Mount was the home of Percy Neame, a local brewer, who maintained its cricket ground for Faversham Cricket Club. Like many large houses, it was converted into a hospital for wounded soldiers during the First World War.

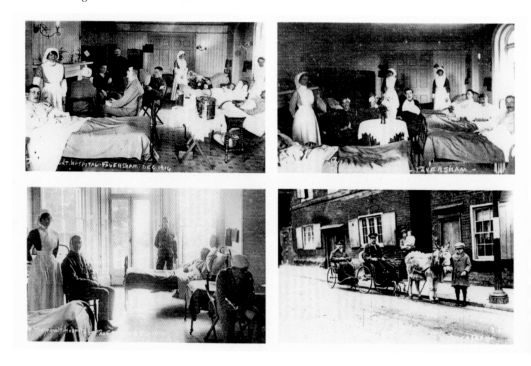

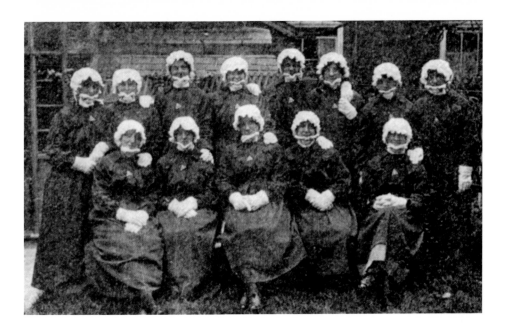

The Great Explosion of 1916

Amidst the frantic scramble to supply, a grievous accident occurred at Uplees, the large gunpowder site near the coastline. Over 100 people were killed; the blast broke windows on the opposite side of the Thames estuary. A mass grave in Faversham Cemetery is shown below. The female munitions workers were called canaries because the chemical impregnated their skin and made them yellow. By 1934, ICI owned all the gunpowder factories. Due to Faversham's vulnerability to air attack, and the likelihood of future hostilities, they were closed down.

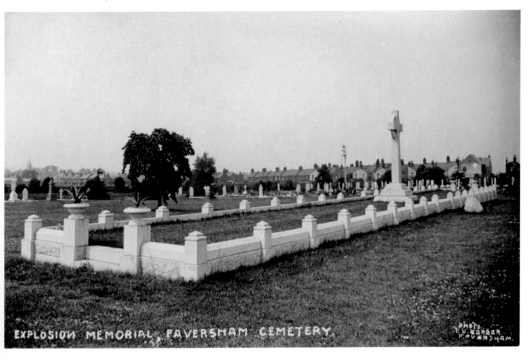

EXPLOSION MEMORIAL, FAVERSHAM CEMETERY.

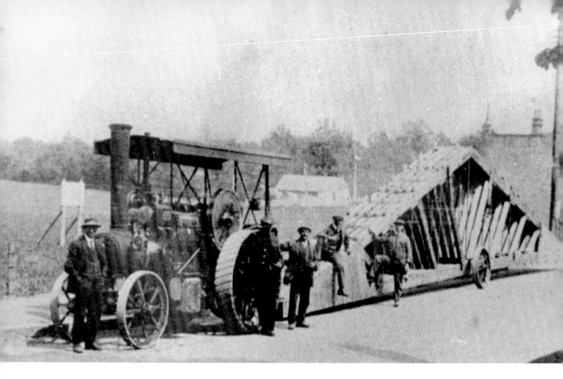

Airfields

After the end of the First World War, roof trusses from Throwley Aerodrome were recycled by Pullen's Garage in Sittingbourne. On the same ridge of the North Downs, flying continues at the Challock home of Kent Gliding Club.

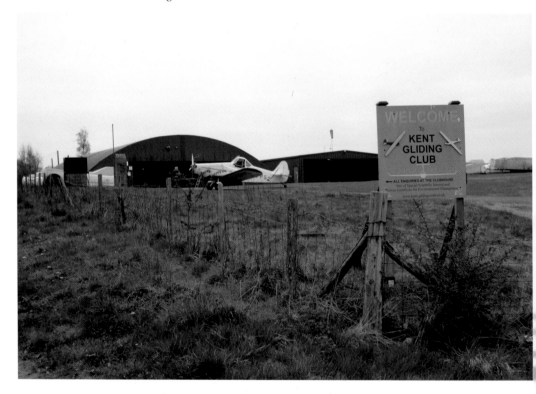

Chart Mills

In around 1560, a factory to manufacture gunpowder was set up in the St Ann's area of the town. Its location was determined by the presence of a freshwater stream, which was harnessed to provide power for the wheels that crushed and mixed the three ingredients. Charcoal, one of the three, was provided by local alders; saltpetre and sulphur were brought to the site. Saved from dereliction by the Faversham Society, the fully restored works are now open for public viewing.

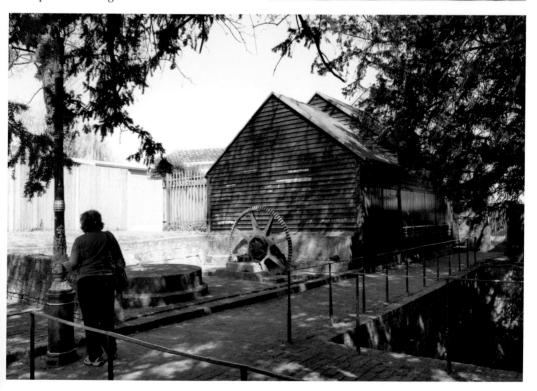

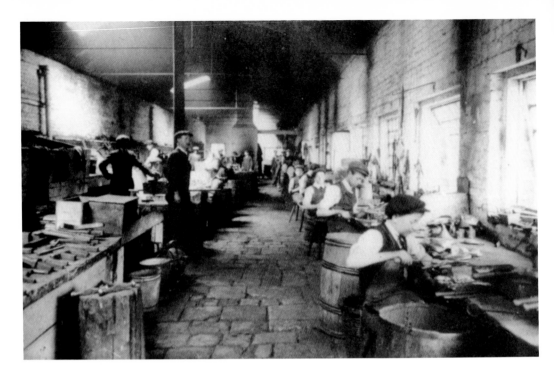

Oare Gunpowder Works

In the seventeenth century, another site for making gunpowder developed at Oare. Two enterprises vied with each other, both founded by Huguenot refugees, who improved on English techniques. Water power was used, and a network of streams provided transport channels. To create blast screens, trees were planted between the safely spaced-out buildings. Shut off from civilisation since closure in 1934, the woodland and its industrial archaeological remains became a nature reserve in 2004. Below is the visitor centre.

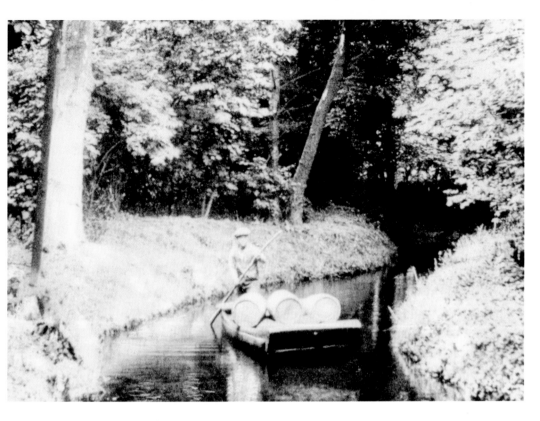

Transporting Gunpowder
Due to the ever-present danger of explosion, it was necessary to be extremely cautious when moving gunpowder in bulk; steam engines were out of the question. Punts, barges, and horse carts were mainly used.

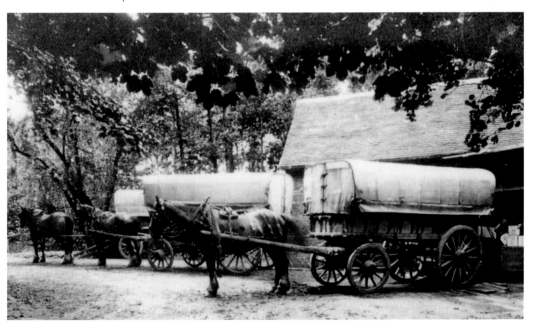

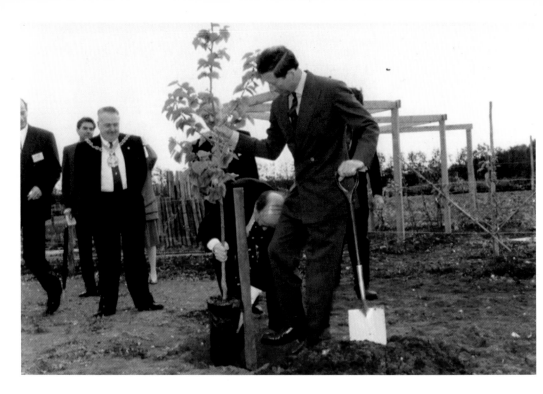

Brogdale Fruit Collection

Purchased from the Barrie family, Brogdale was set up to house a definitive collection of fruit varieties in the heart of the North Kent horticultural belt – renowned for the fecundity of its orchards since at least Tudor times. Funding cuts threatened its closure in 1989, but loans from the local authority and the Duchy of Cornwall saved the day. One of its saviours, Prince Charles, is pictured planting a commemorative mulberry tree.

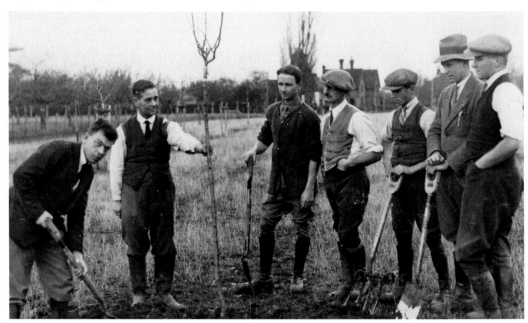

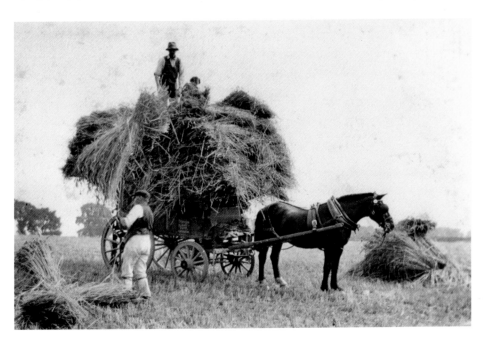

Farm Machinery

A century ago, horse power was universal in agriculture. Today, highly technical machinery is used. These glimpses of work on two local farms illustrate this revolution.

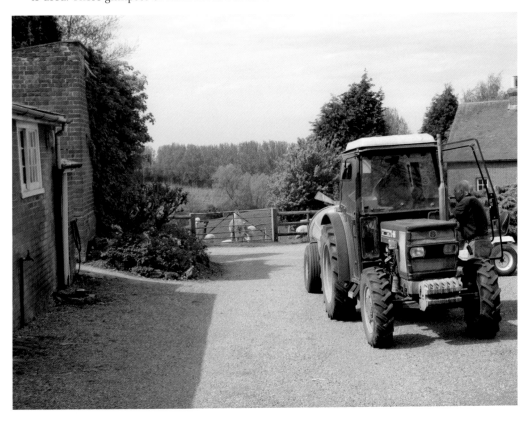

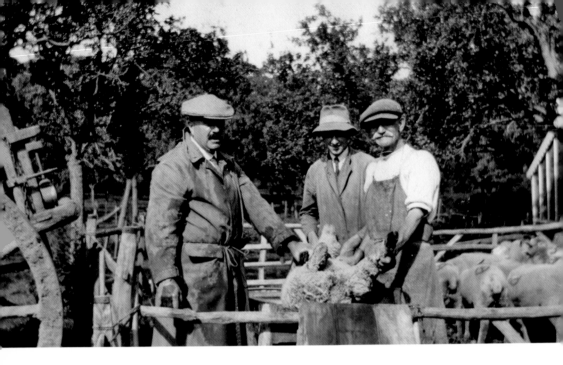

Shepherding

This shot, taken a century ago, is marvellous composition of stockmen attending to their flock. The Kent, or Romney, breed is still reared in traditional cherry orchards, as seen below. The lambs gambol in the spring sunshine beneath the blossoming fruit trees.

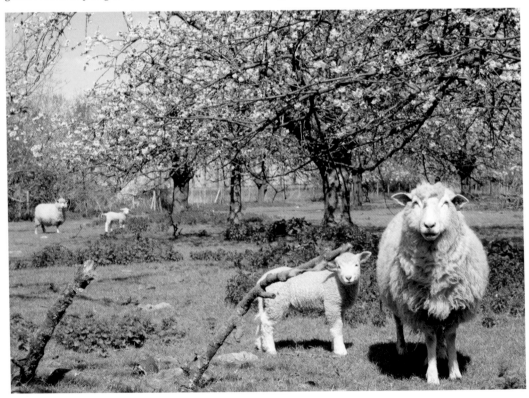

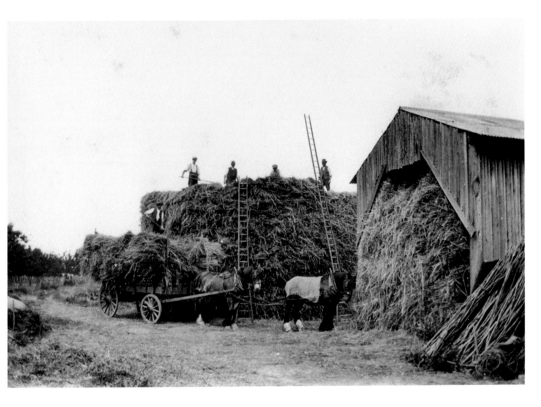

Farming In Yesteryears
Here are glimpses of stack building and threshing, two very labour-intensive tasks, at Brogdale Farm around a century ago.

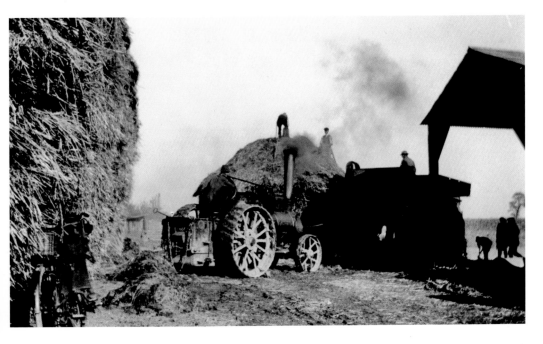

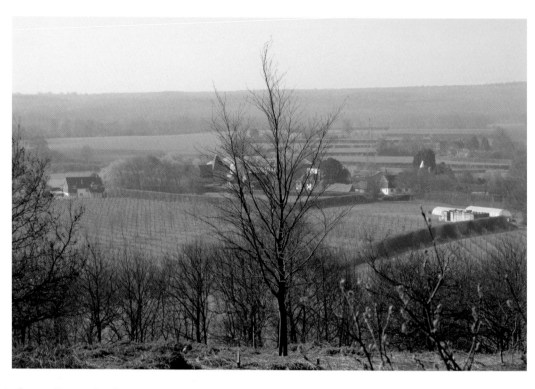

The Darling Buds of May

The garden of England lying peacefully in the early morning mists of April at the summit of Perry Woods shows little sign of the blossom to come. By May, however, the orchards are a riot of pink and white flowers.

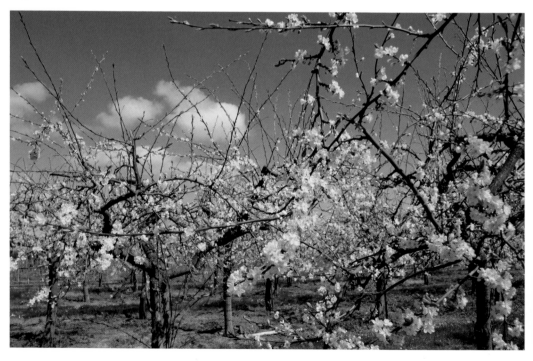

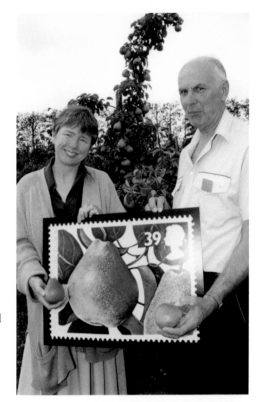

'Known by Their Fruits'
This is the motto on the coat of arms of Swale Borough Council, the District Local Authority governing Faversham. When Royal Mail issued a set of stamps depicting fruit they were shown in large mock-ups at Brogdale. Below, a local shopper is testing the quality of local produce at Macknade, which is renowned for its extensive range of fresh food.

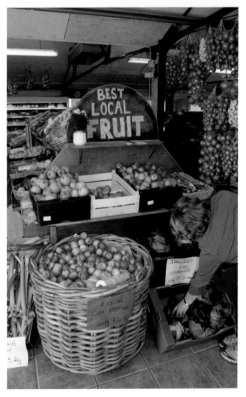

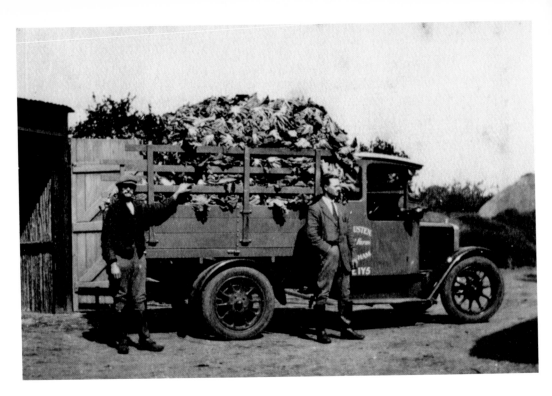

Local Horticulture

Mr T.E. Austen of School Lane, Faversham, poses beside a load of produce just harvested. He looks obviously proud of his crop and his smart vehicle. His telephone number, 1Y5, is painted on the side of the cab. Almost a century later, in a quiet corner of Monks Farm, Norton, the late Robert Bray attained the title of 'Britain's Best Fruit Grower'.

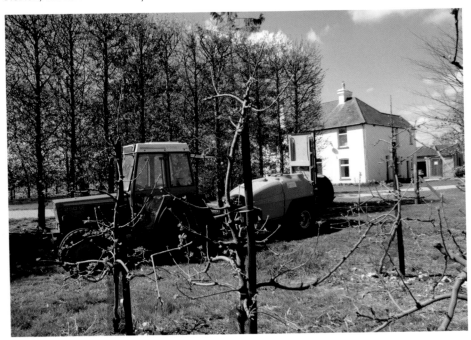

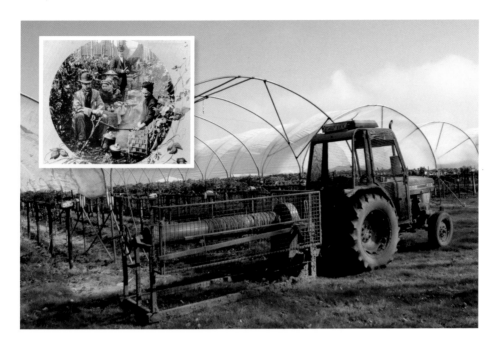

Seasonal Workers
The majority of itinerant farm workers now come from abroad. The strawberry fields above are largely tended by young labourers from Eastern Europe. In contrast, the hop pickers shown arriving at Selling station with their chattels below were *en famille*. They lived in purpose-built huts during their seasonal stay.

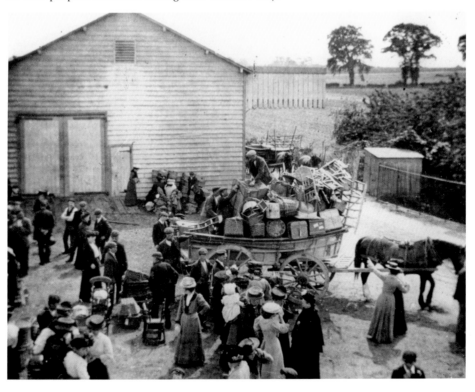

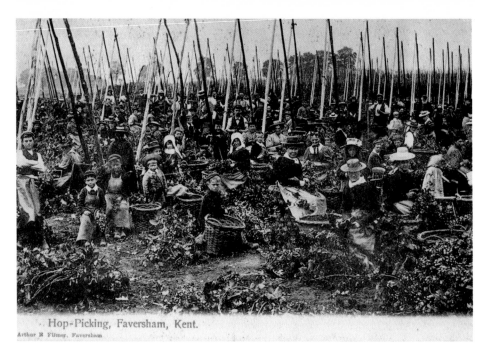

Hop-Picking, Faversham, Kent.

Arthur H Filmer, Faversham

Hop Picking

Once considered 'a pernicious weed' according to a parliamentary petition of 1428, hops were first planted in Kent in 1524. The climate, soil, large labour force, and growing metropolitan market for beer consumption ensured future crop expansion. The Edwardian picture above shows pickers and their families stripping the binds of pungent flowers in a hop garden, a task now achieved mechanically. The view below illustrates a modern hop field in April, strung and ready for the bines to shoot rapidly up.

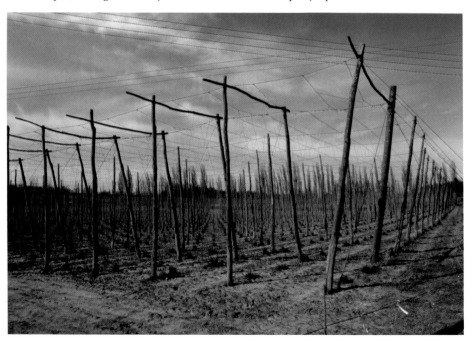

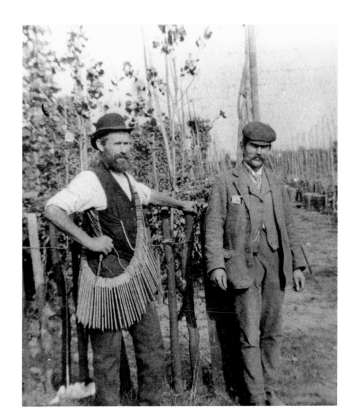

The Tally Man

The tally man was employed by hop farmers to record the piece work achieved by hop pickers. Each worker or family's output was marked on the wooden tags dangling from his neck. Often, pay was low and only received at the end of the season. Accordingly, much charitable work was carried out by religious missions.

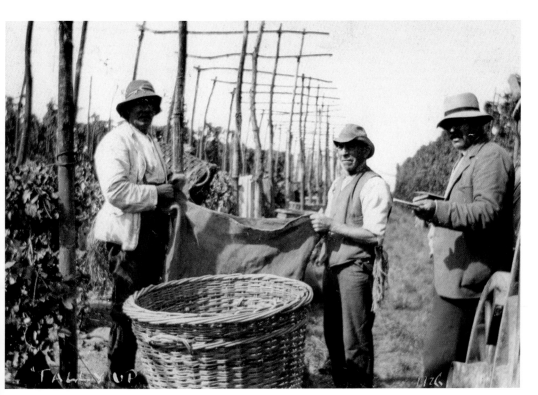

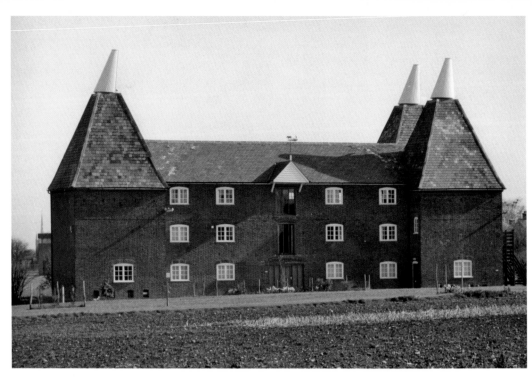

Oast Houses (I)

This magnificent oast house has, like many in the district, been converted into a valuable residential property. In this case, the majesty of the original structure has been retained.

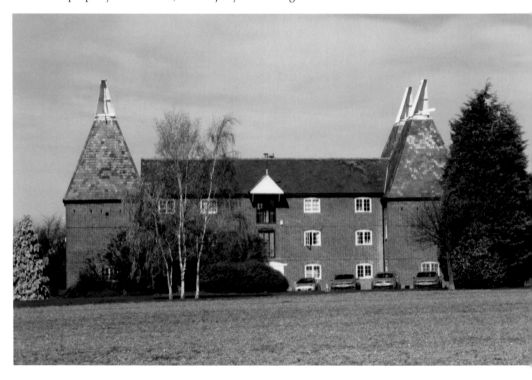

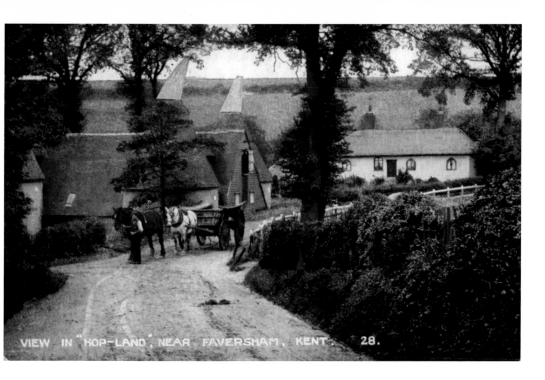

VIEW IN "HOP-LAND" NEAR FAVERSHAM, KENT. 28.

Oast Houses (II)

In rolling countryside near Selling, many hop gardens can be found. Looking at the picture above, you can appreciate the old, leisurely way of country life. Today, the earlier oast houses have been replaced with a battery of more efficient ones on the ridge above this vale.

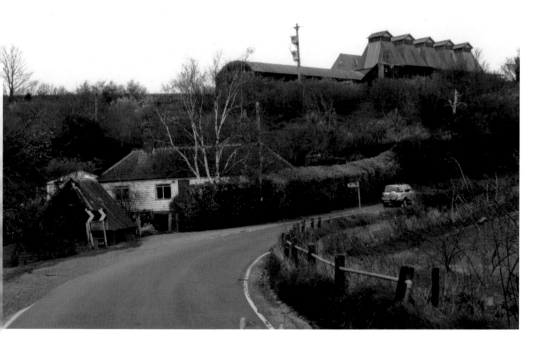

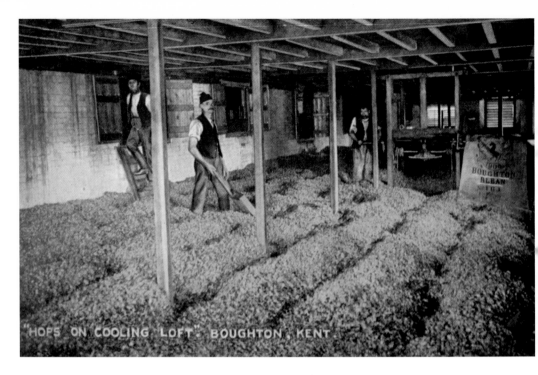

Hop Drying

Just as skilled as the cultivation of hops was their preparation for sale to brewers. The scene depicted here is the cooling operation after the hops have been heated in an oast kiln. The charcoal used to fuel these buldings was produced in the woodlands rising above the dip slope of the North Downs, south of Faversham. Below, Arthur Partis is about to leave a local farm with his lorry loaded with sacks of hops.

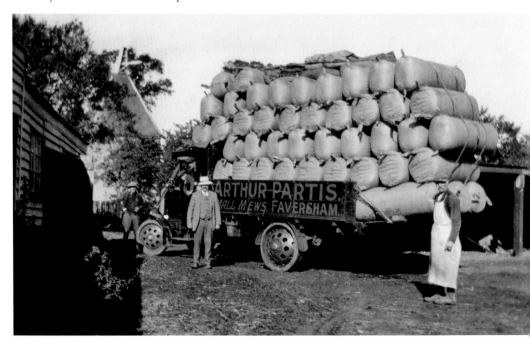

Rigden's Brewery
Once the home of the Rigden family, this building later became the Whitbread offices. It is now an Italian restaurant. It is an old Wealden hall house that has been gradually gentrified.

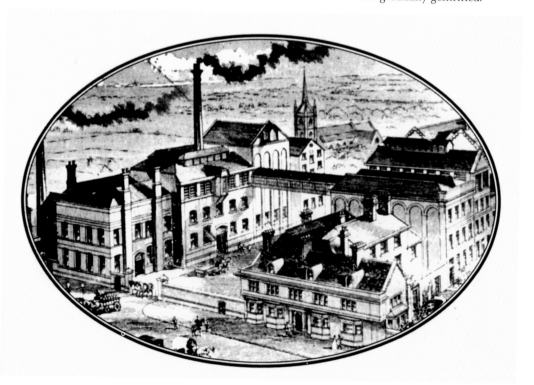

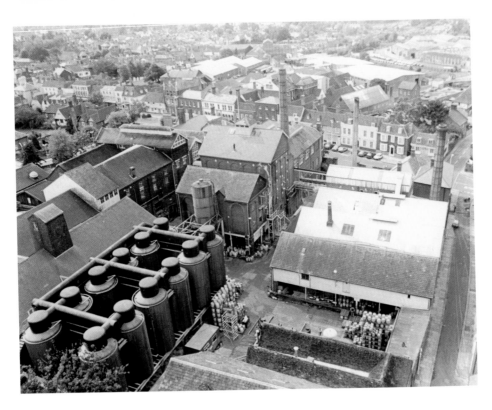

Whitbread Brewery

The aerial view above shows Whitbread Brewery in full production at the centre of the town before its closure. Originally used for beer production by Rigden's and later Fremlins, the valuable site has been mostly taken over by Tesco, which provides the town with one of its main car parks.

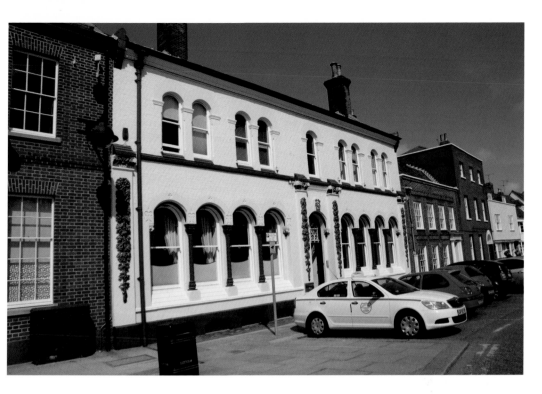

Shepherd Neame's Offices, Court Street
The exterior of Shepherd Neame's main offices in Court Street are appropriately decorated with cement hop bines. Further south, a medieval shop has been converted into an outlet for the range of brewery products.

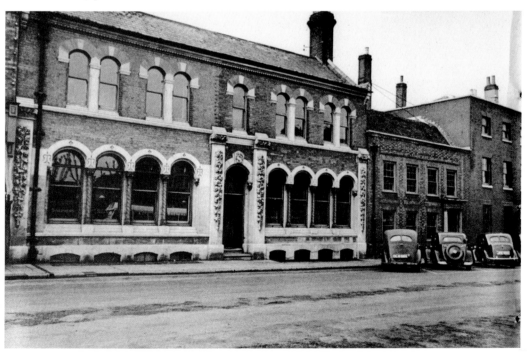

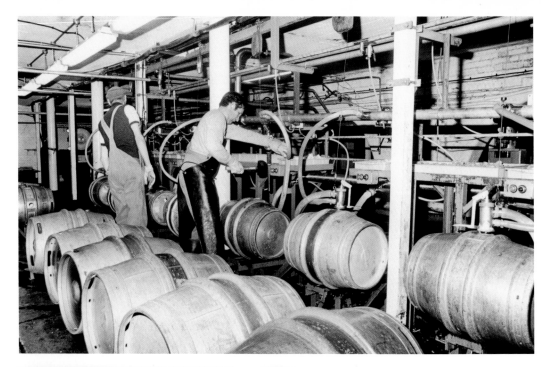

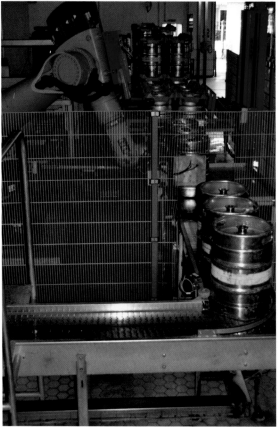

Packaging Beer
These pictures show subtle changes in beer packaging. The barrels are rolling off the production lines at Whitbread and Shepherd Neame. The former were filled by hand, whereas the modern system at Shepherd Neame is fully automated.

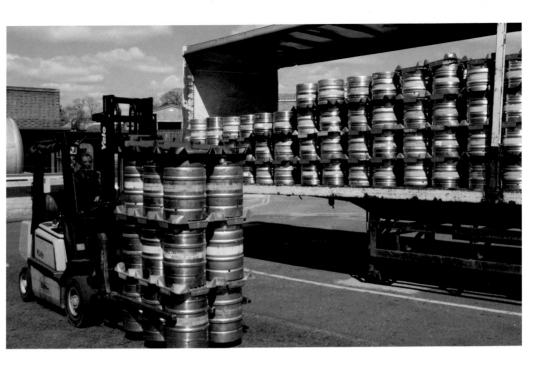

Draymen

Nearly everything has changed in these contrasting pictures. The motive power is now diesel not horse as shown in this very old photograph. Kegs are made from metal, not wood. However, most importantly, the superb quality of Shepherd Neame's beer remains unaltered.

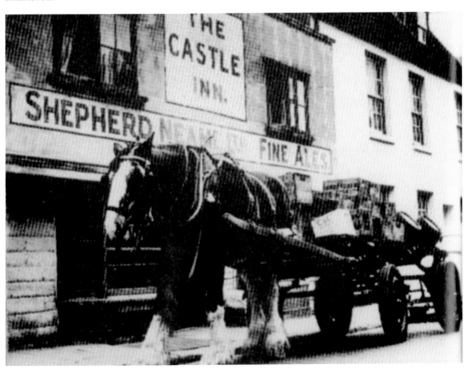

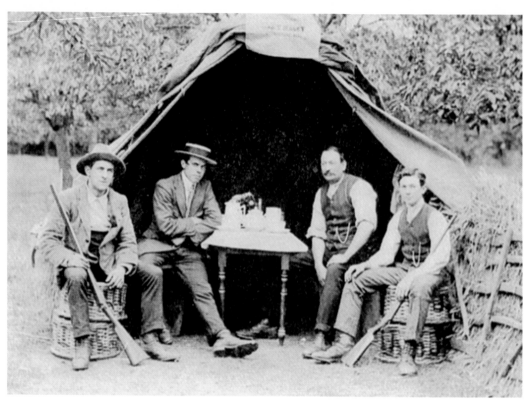

Sharp Shooters

The countrymen above are resting from a spell of bird minding in a laden cherry orchard. Below, sport is the seriously male pursuit of one Mr Clark's 1910 shoot.

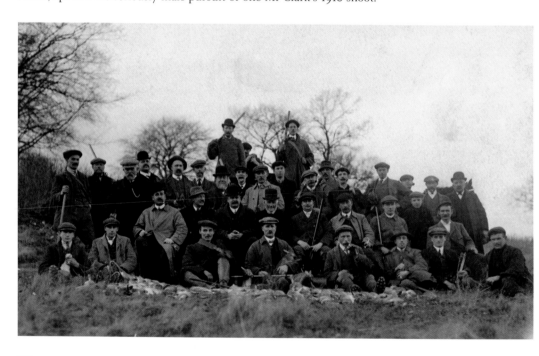

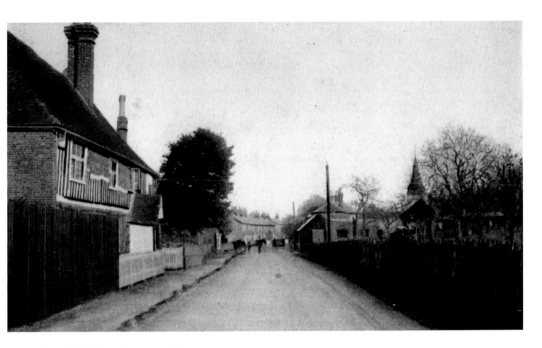

The Birthplace of James Pimm

James Pimm started life as the son of a farmer from Newnham. He became the proprietor of an oyster bar close to the Bank of England's headquarters. To aid his customers' digestion, he created a gin-based liquor which, mixed with herbs and quinine, formed the essence of his 'Number One Cup'. Now this quenching summer tipple is available at quintessentially English outdoor events such as Henley, Glyndebourne, Wimbledon, and the polo finals.

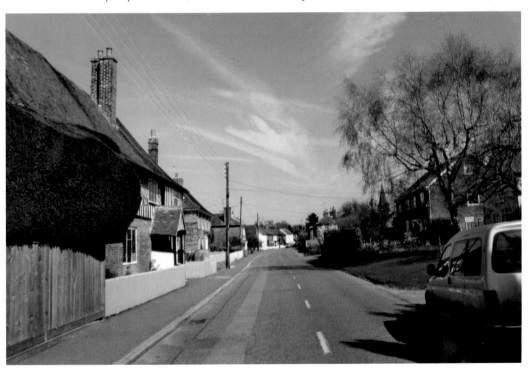

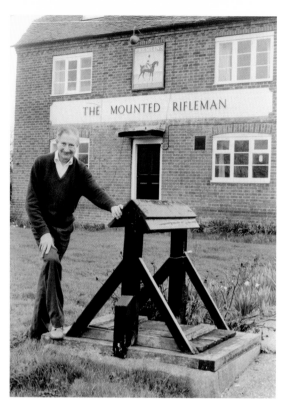

The Mounted Rifleman

This redundant public house was named after the militia who guarded the coastline against smuggling in the eighteenth century. Since early times, smuggling and owling (the illegal export of wool) have been rife along this shoreline of hidden creeks and inlets close to the continent. The last landlord was Bob Jarret, who with great ceremony would disappear down steps into a cellar to pour pints of cask beer. Now in his eighties, Mr Jarret has retired and his hostelry is the attractive home of Peter and Maureen Benson.

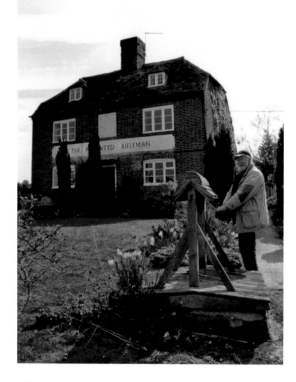

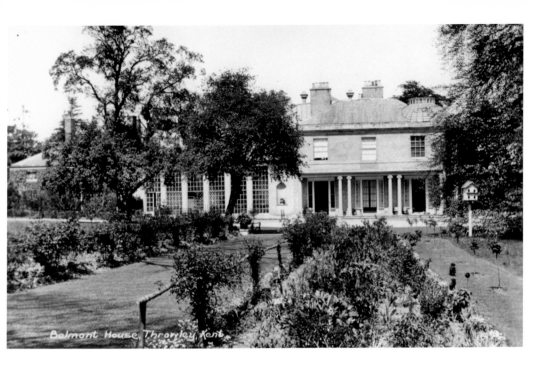

Belmont House

The original house was built in 1769 for a storekeeper in Faversham Powder Works. Enlarged by an army colonel, who hired Samuel Wyatt to execute his superb design, the estate was bought at auction by General George Harris in 1801. The first Lord Harris distinguished himself by defeating the Sultan of Mysor in 1798 at the battle of Serringapatan. His prize money for this feat was £150,000.

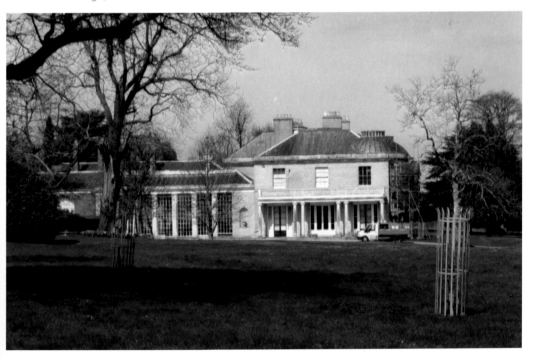

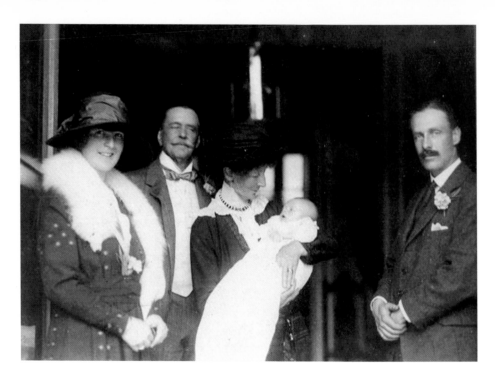

Three Generations of Harris at Belmont

The gentleman with the winged collar is the scion of the Harris family, famous for being one of England's finest cricket captains and pioneer of the Ashes series with Australia. George Harris' son (on the right) became a stockbroker and an internationally renowned collector of clocks and watches. The baby just christened would be the bachelor Captain Harris, the last of this line. His career was in farming and estate management.

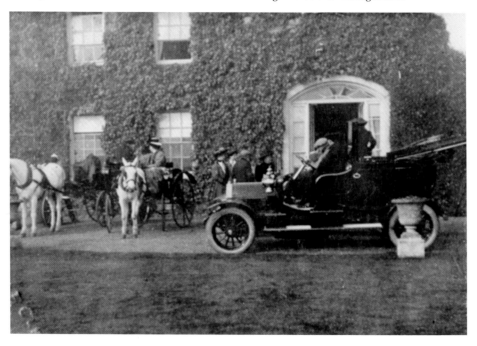

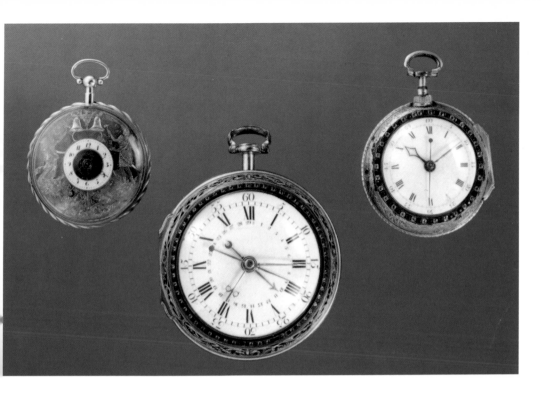

Belmont Orangery and Collections

Belmont's orangery is shown to the left of the portico. It was a clever device used by eighteenth century architects to link old buildings to large extensions. Still producing citrus fruits today, it is a feature much admired by visitors. Belmont's collection of clocks and watches, meanwhile, is considered to be the finest in private hands.

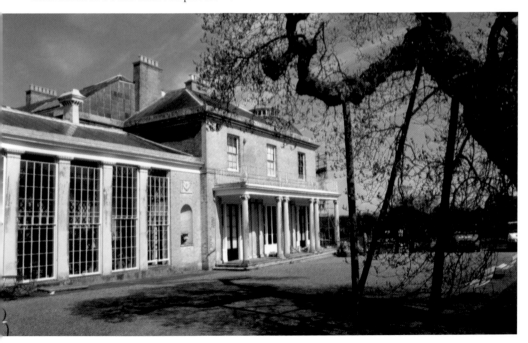

Provender

Reputed to have once been a hunting lodge belonging to the Black Prince, this fabulous half-timbered house has many fascinating associations. Sir Joseph Banks, the horticultural pioneer, married into the Hugessen family, who resided here. It was used by Field Marshal Montgomery as a headquarters for D-Day planning, and then became the home of an exiled Russian prince. His descendent Princess Olga Romanott is currently undertaking a detailed renovation, for which she is employing architect Ptolemy Dean of the much acclaimed *Restoration* television programme.

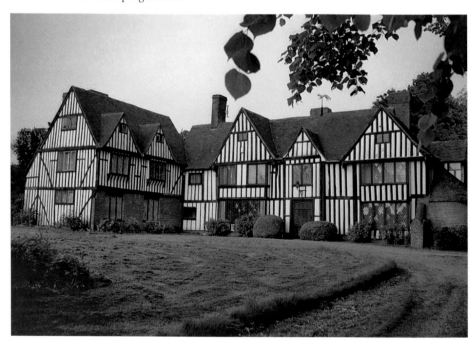

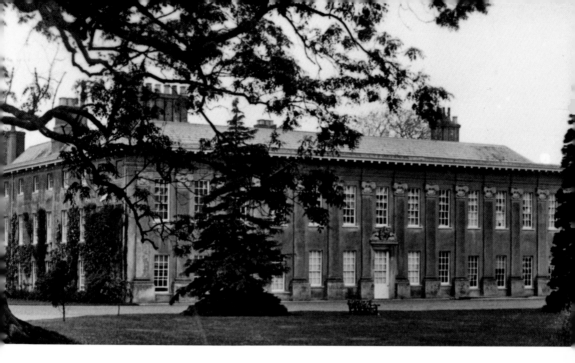

Lees Court, Sheldwich

Built for Sir George Sondes, a prominent royalist, in 1654, this early example of a classical mansion was the scene of fratricide. One of the owner's sons killed his sleeping brother with a cleaver. He was hanged at Penenden Heath for this atrocity. The house is now converted into luxury flats. Some of the estate's lands grow crops used in the manufacture of natural toiletries.

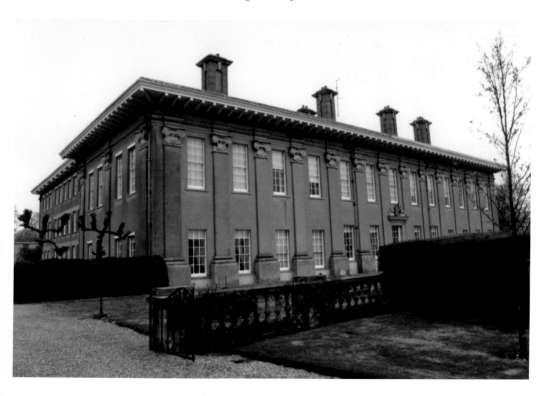

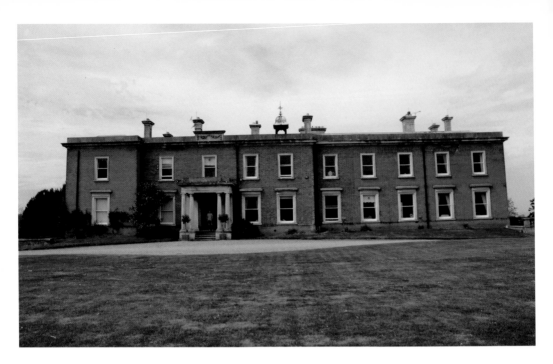

Mount Ephraim

Mount Ephraim has been the home of the Dawes family for some 300 years. It is attractively sited atop a hill overlooking 800 acres of productive orchards, with views of the north Kent coastline beyond. Ten acres of Edwardian gardens attract a host of visitors and are the venue for outdoor plays and musical concerts.

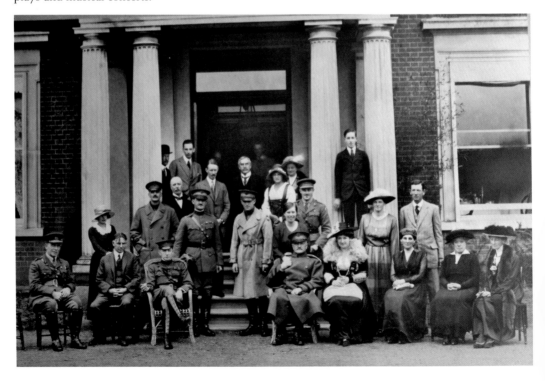

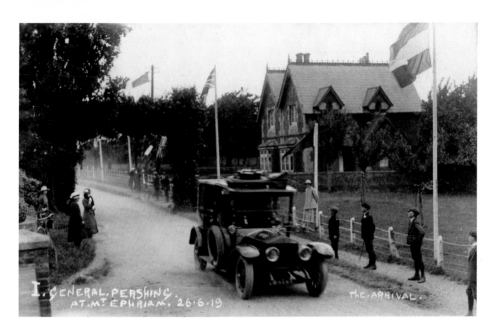

General Pershing Visits Mount Ephraim

General Pershing sweeps along the lane approaching Mount Ephraim in a Rolls-Royce Silver Ghost. He was soon to greet General Dawes who he believed he might be a relation. Black Jack Pershing had started his career as a teacher. To advance his education, he became a soldier and ultimately Commander-in-Chief of the American Expeditionary Force. In 1932, he won the Pulitzer Prize for history after writing his autobiography *My Experience of War*. The gardens remain exceptional.

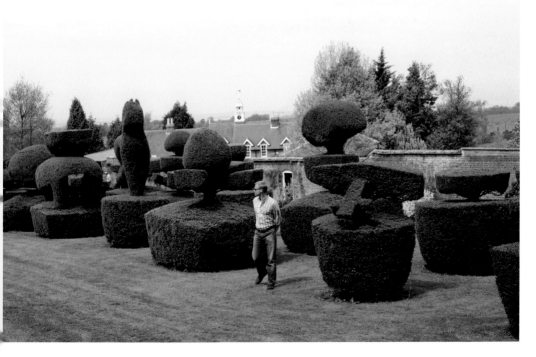

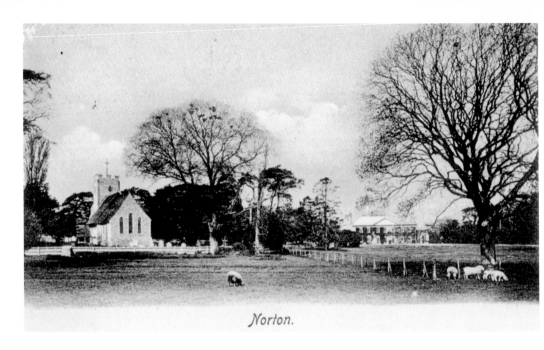

Norton.

Norton Court

Stephen Gray (1666-1736), known as 'the father of electricity', used Norton Court, home of John Godfrey, for some of his experiments in conductivity. Running out of space, he transferred his research to Granville Wheler's nearby seat, Otterden Place. Here he succeeded in transmitting an electrical charge over hundreds of feet. He died poor and relatively unknown, but it is now hard to overestimate the significance of his discoveries.

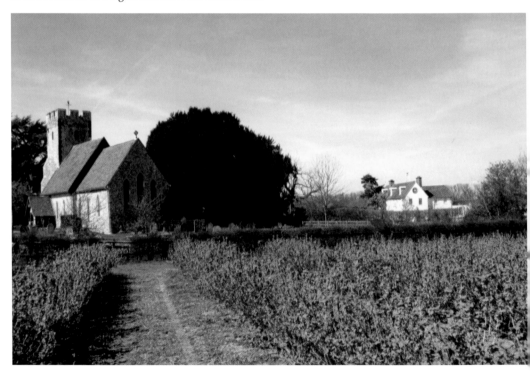

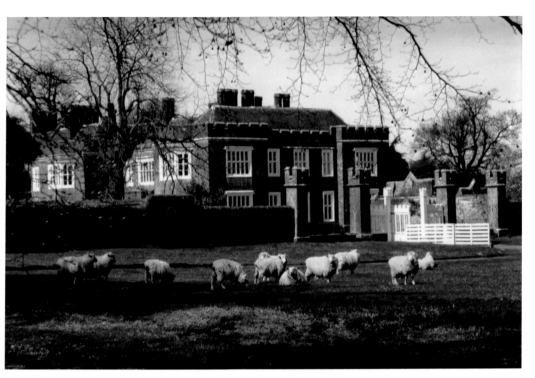

Otterden Place

Conservative MP Granville Wheler of Otterden Place was a supporter of Joseph Chamberlain's Tariff Reform League, established in 1903. A grassroots pressure group, it supported a British Empire trading bloc, which would compete against the United States and Germany. Its opponents, primarily the Liberals, claimed it would lead to higher food prices. The League split the party, a major factor in securing a landslide election victory for the Liberals in 1906.

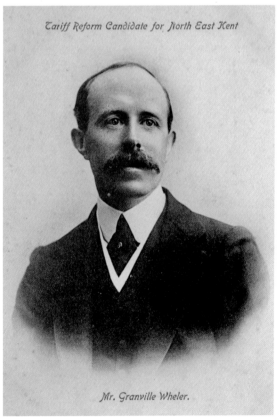

Tariff Reform Candidate for North East Kent

Mr. Granville Wheler.

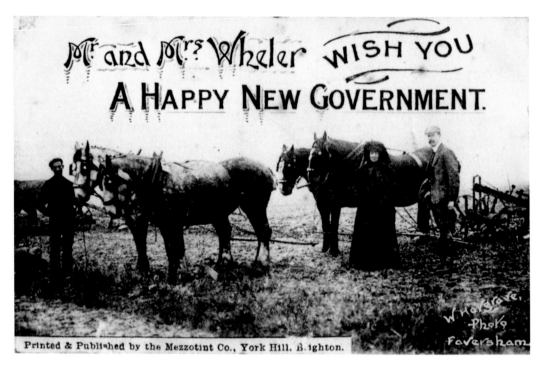

Mr and Mrs Wheler WISH YOU
A HAPPY NEW GOVERNMENT.

Printed & Published by the Mezzotint Co., York Hill, Brighton.

General Elections

A promotional postcard supporting Granville Wheler shows him with a ploughing rig on his estate and wearing a tweed knickerbocker suit. By 1926, a less gentlemanly approach to politics had emerged. A major confrontation between the labour unions and employers ended in a general strike. The predominantly male crowd are seen awaiting the victory of Conservative candidate Adam Maitland, the invumbent, during the general election of 1929 (which resulted in a hung parliament).

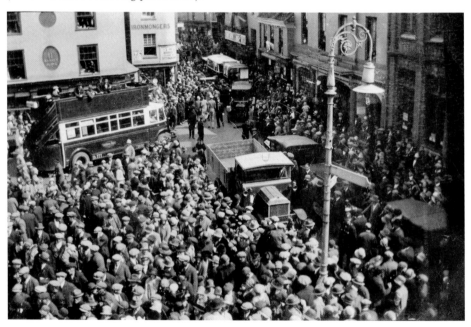

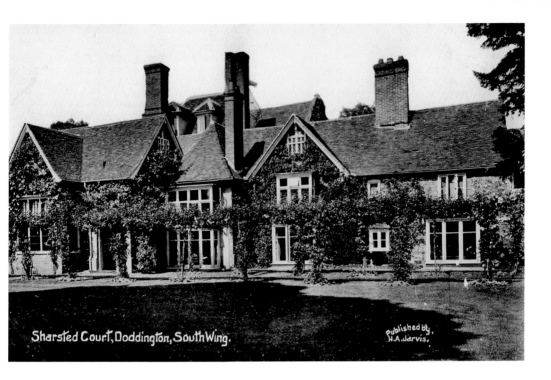

Sharsted Court, Doddington, South Wing. Published by H.A. Jarvis.

Sharsted Court

A rambling mansion set within woodlands high above Newnham Valley, this was the country house of the Faunce-De-Laune dynasty for over 200 years. It was purchased by Canon Wade in 1966. Bequeathed to his three children, the estate is now occupied by two of his heirs and their respective spouses and occasionally by his daughter Virginia Wade, the 1977 Wimbledon tennis champion, on her visits from America.

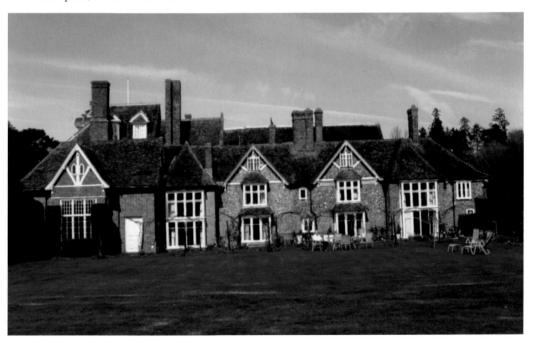

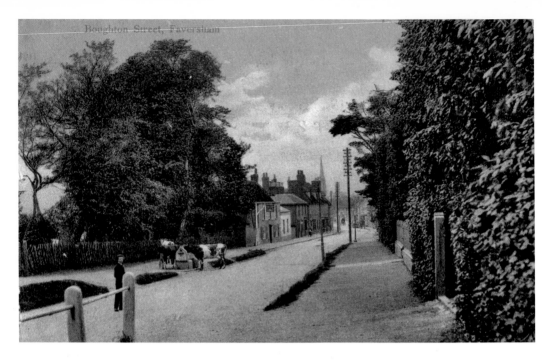

Boughton Street

This picture, taken from an Edwardian postcard, shows a bucolic image of the village of Boughton on the London-to-Canterbury main road. The cattle drinking at the horse trough would likely cause a traffic incident today, although the worst of the traffic has been diverted; Boughton has been bypassed with a dual carriageway.

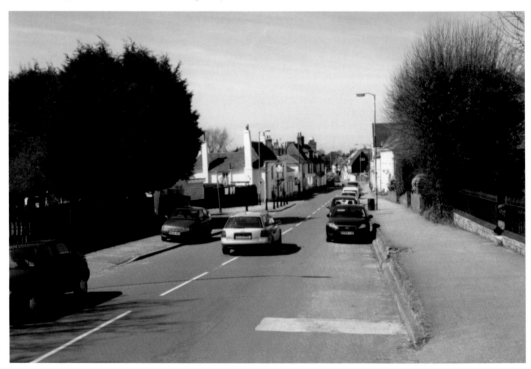

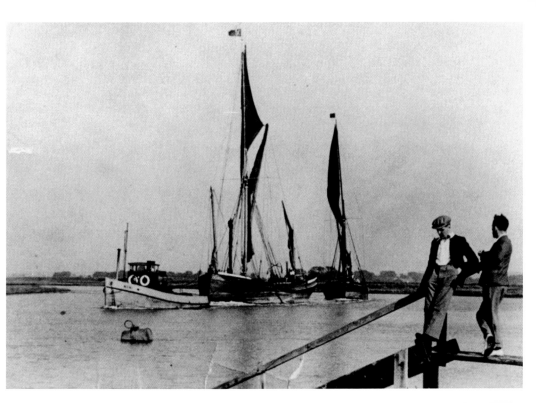

Thames Sailing Barges
The picture above shows two sailing barges being towed into port. They were a ubiquitous sight, plying their trade along the Kent coastline. No longer conveying bulky loads, some have been preserved as floating homes or are hired out for tourist trips.

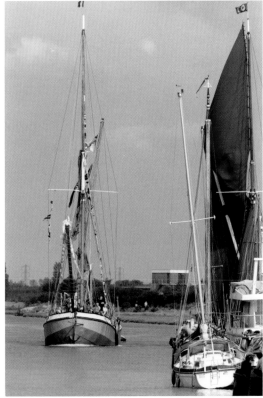

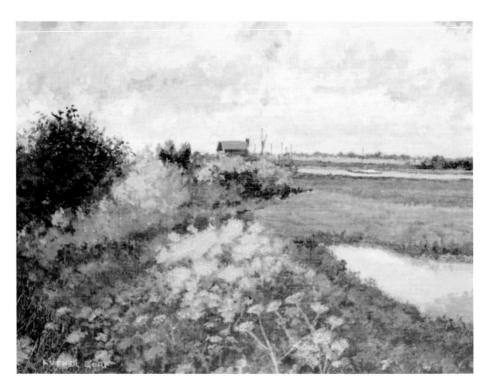

The Marshes

Above is a reproduction of a painting of Faversham Creek by local artist Luther Gorf. Below, further downstream, is a vista of Oare Creek, with boats from Hollow Shore Sailing Club. The wetlands are very popular with twitchers, who gather with ocular equipment to observe a wide variety of visiting wildfowl.

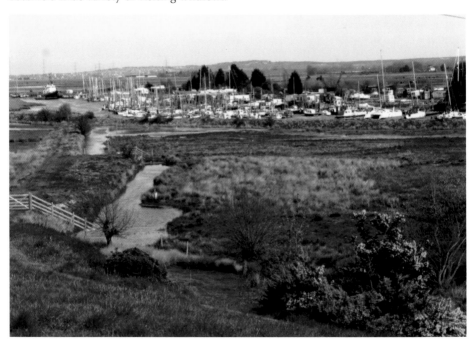

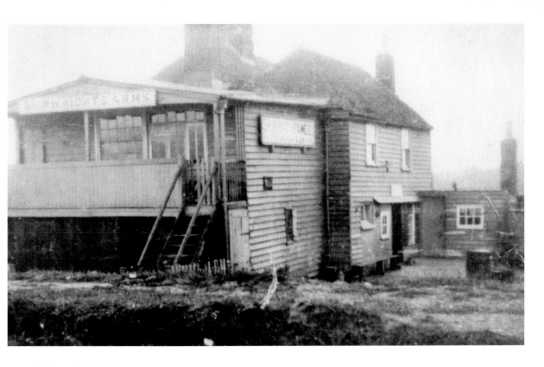

Shipwright's Arms

At the juncture of Oare Creek and Faversham Creek is the Shipwright's Arms. This quaint old inn, isolated on the marshes, is a favourite watering hole for thirsty sailors.

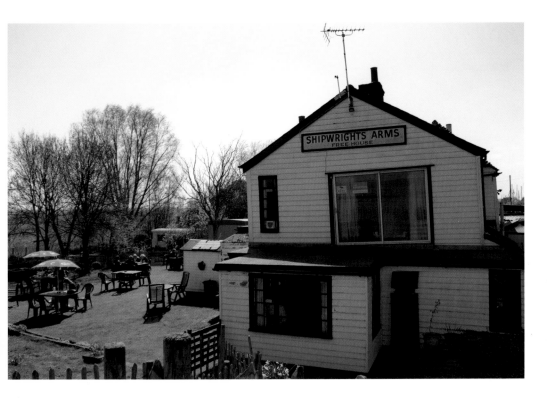

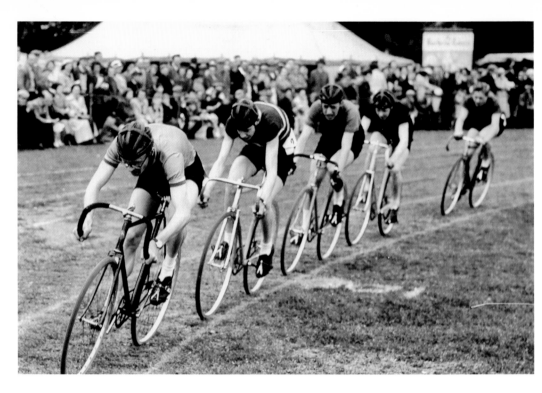

Cyclists

Above are Faversham cyclists at a sporting event. Two generations later, recreational mountain bikers are caught having a breather after a Sunday morning sprint in Perry Woods.

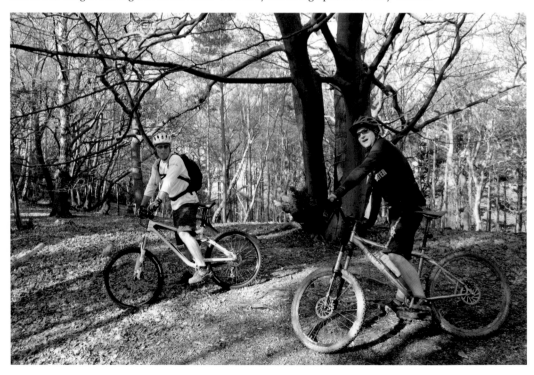

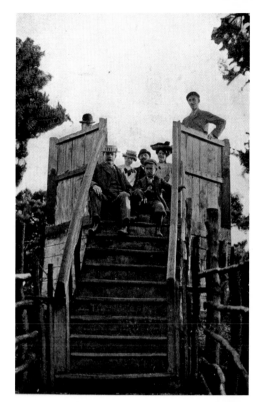

The Pulpit, Perry Woods
At the pinnacle of Perry Woods is a structure enabling walkers to look out over a beautiful vista of the rolling Kent countryside. The nature reserve, just outside Faversham, comprises 150 acres of woodland. It is open for the free enjoyment of wildlife and the public alike.

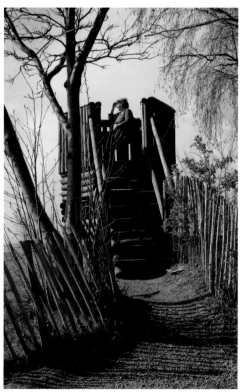

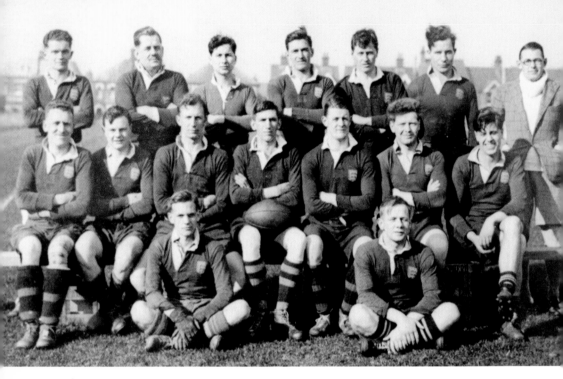

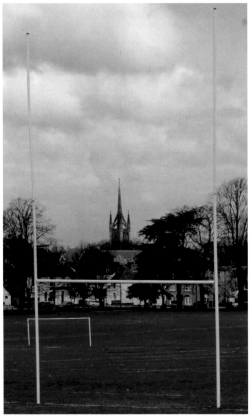

Faversham Rugby Club
Players from the 1930s seen sitting for a formal portrait. In the centre is the captain, J. Wills. He was the director of a local brick-making firm and went on to serve his country as an army officer in the Second World War. The present goalposts are situated at Faversham's recreation ground, here viewed from the clubhouse.

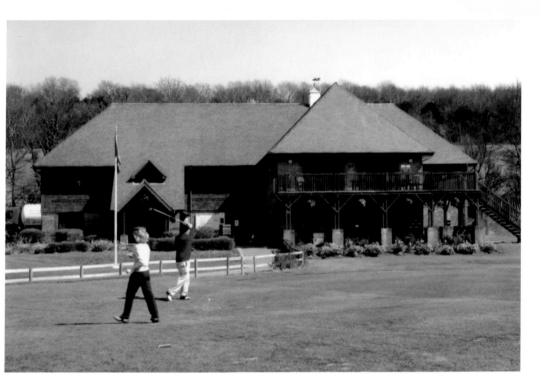

Faversham Golf Club

Situated on the Belmont Estate, Faversham Golf Club is one of the most beautiful in the country. The holes are set within wooded vales and challenging, undulating terrain. A new clubhouse has replaced the old one, which is depicted below, with members' parked cars. Players are still able to play a round accompanied by the peaceful sound of cock pheasants croaking in the undergrowth.

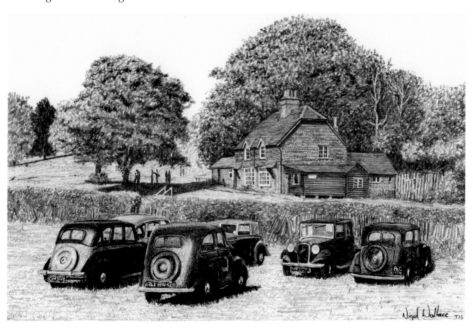

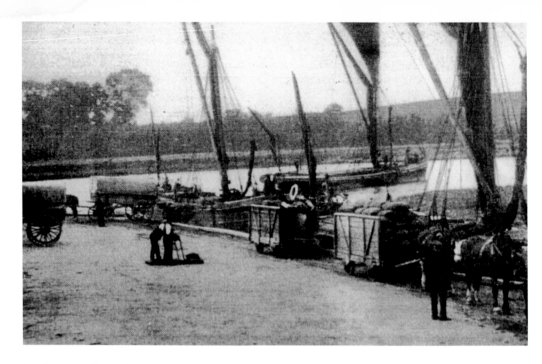

Explosives at Faversham Creek.

Acknowledgements

Thanks go to Keith Chisman, Chris Shipley, Maureen Benson, Mr Dawes of Mount Ephraim, Jill Stewart of Faversham library and Sean Caveney, the devoted gardener of Bob Geldof. A special debt of gratitude is owed to Vic Streeting, whose invaluable assistance was greatly appreciated.